IMAGES
of America

THE QUEENSBORO
BRIDGE

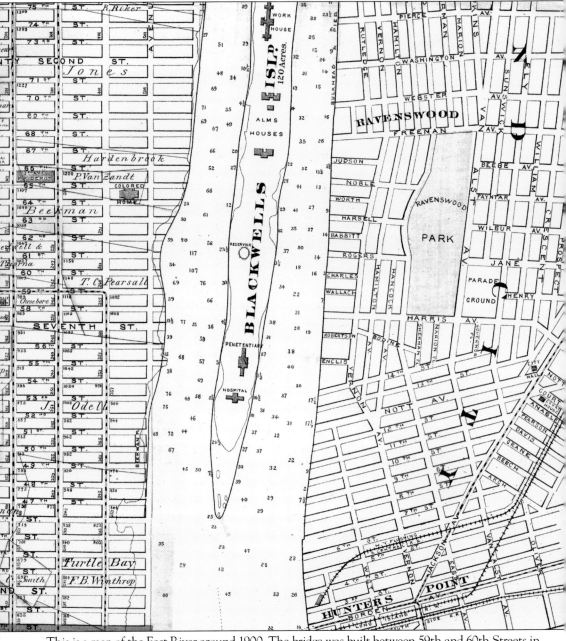

This is a map of the East River around 1900. The bridge was built between 59th and 60th Streets in Manhattan and Jane Street in Queens. (Courtesy of Greater Astoria Historical Society collection.)

On the cover: A Manhattan-bound Second Avenue elevated train makes a turn off the Queensboro Bridge. (Courtesy of New-York Historical Society collection.)

IMAGES
of America

THE QUEENSBORO
BRIDGE

The Greater Astoria Historical Society and
the Roosevelt Island Historical Society

ARCADIA
PUBLISHING

Published by Arcadia Publishing
Charleston, South Carolina

Printed in the United States of America

Library of Congress Catalog Card Number: 2007926872

For all general information contact Arcadia Publishing at:
Telephone 843-853-2070
Fax 843-853-0044
E-mail sales@arcadiapublishing.com
For customer service and orders:
Toll-Free 1-888-313-2665

Visit us on the Internet at www.arcadiapublishing.com

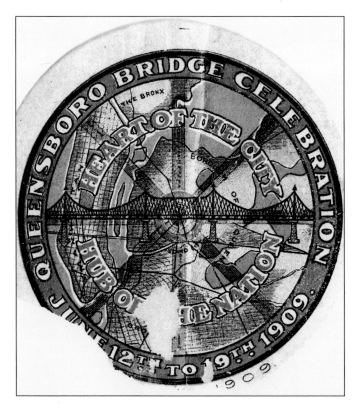

A rare decal celebrating the Queensboro Bridge opening boasts the motto "Heart of the City, Hub of the Nation." (Courtesy of Robert Singleton collection.)

CONTENTS

ACKNOWLEDGMENTS

Thank you to Robert Singleton of the Greater Astoria Historical Society (GAHS) and Judith Berdy of the Roosevelt Island Historical Society (RIHS) for envisioning this project and being responsible for most of its research and writing.

We would like to thank RIHS's Ursula Beau-Seigneur and GAHS's Richard Melnick, Walter Kehoe, Matt LaRose, and Debbie Van Cura for additional writing and research. Their knowledge was superb, and without their dedication this book would not have been written. Special mention for GAHS's Matt LaRose, who scanned the images, and Stephen Leone, Vincent Seyfried, and Bob Stonehill, whose marvelous collections underpinned much of the book.

Our thanks to the New York City Municipal Archives—Leonora Gidlund, director, and Michael Lorenzini of the photography department. A special thanks to Lorenzini for researching the work of Eugene de Salignac, bridge photographer.

Thanks to Dave Frieder, our friend, who loves to climb in the superstructure of our bridges and bring us the most remarkable views of the city and its bridges.

To many individuals and organizations who have contributed their time and knowledge to our book: Judith Berdy, Carnegie Mellon University, Frank Carrado, Oliver Chapin Archives, Dave Frieder, George P. Hall and Sons Archives, Wanda Katz, Dan Lenore, Stephen Leone, the Mathews family, Richard Melnick, Steven Melnick, Museum of the City of New York, Municipal Art Society, New York City Parks Department, New York Road Runners, New York Transit Museum, New-York Historical Society, Pei Cobb Freed and Partners Architects LLP, Queens Borough Public Library, Queens Chamber of Commerce, Allan Renz, Eleanor Schetlin Archives, Vincent Seyfried, Bob Stonehill, and Robert Singleton.

Let us tip our hats to the New York City Department of Transportation and its engineers and contractors who are restoring and maintaining the Queensboro Bridge. A final thank-you to Thomas Rainey, Gustav Lindenthal, and Henry Hornbostel and to all the strangers who tell us their stories of crossing the bridge in years past.

We also want to remember the late Tom Jackson, trustee, benefactor, scholar, and friend to GAHS, whose untimely passing prevented him from coordinating this project.

Visit our Web site at www.queensborobridge.org.

INTRODUCTION

Over the great bridge, with the sunlight through the girders making a constant flicker upon the moving cars, with the city rising up across the river . . . the city seen from the Queensboro Bridge is always the city seen for the first time, in its first wild promise of all the mystery and the beauty in the world.

—F. Scott Fitzgerald, *The Great Gatsby*

The Queensboro Bridge, a steel giant of graceful symmetry, has long been a source of inspiration for artists, songwriters, and authors. The photographer Dave Frieder wrote, "I have climbed this bridge five times and photographed it from every possible angle. I am very impressed with its design and I continue to be amazed on how massive the structure is—it's a beautiful sculpture. From the top of the trusswork, looking towards Manhattan or Queens, all you see below is a sea of steel. And when viewing the upper roadway one gets the sense of a path leading to forever. With proper care this magnificent bridge can last hundreds of years serving the people of New York City."

Simon and Garfunkel's popular "The 59th Street Bridge Song" put the bridge to music. Filmmakers continue to feature it in such movies as *Manhattan* and *Spider-Man*. Lin Yutang in *Chinatown Family* wrote, "the bridge had the sweep of the sea . . . the grace and strength of a great work of art, and the independence and pride of a beautiful woman." To understand the appeal of the structure is to know the forces which caused its creation.

During the time period covered in this book, locations have evolved multiple names. The bridge itself, formally called the Queensboro Bridge, was called the Blackwell's Island Bridge until just before its opening, and is popularly referred to as the 59th Street Bridge by most of the public. Likewise, Blackwell's Island, renamed Welfare Island in 1921, became Roosevelt Island in 1973. Finally, Bridge Plaza, the approach to the bridge in Queens, was changed to Queens Plaza, a name also adopted by the subway station under it. By contrast the elevated station above the plaza is called Queensboro Plaza.

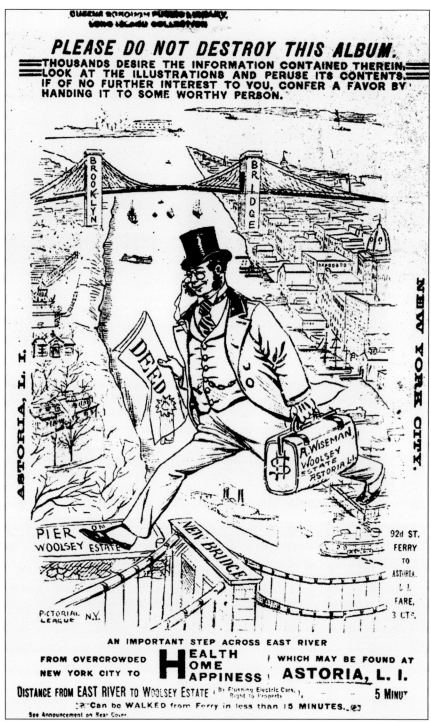

This real estate brochure (1893), which advertised open land in Astoria along 23rd Avenue and Shore Road, emphasized the escape that Queens offered from overcrowding in Manhattan. The bridge, which seems imminent, was still 16 years in the future. (Courtesy of Queens Borough Public Library.)

One

DR. RAINEY'S DREAM

To understand the appeal of this structure is to know the forces that caused its creation.

Settled by the Dutch about 1625, the location and topography favored New York City, with its protected deepwater harbor, and determined its future as a magnet for international commerce. More than 75 bridges link the islands and mainland of the metropolis. The major spans constructed in the late 19th and early 20th century reflect the spirit of enthusiasm and determination of their age. Designed by creative engineering geniuses, these beautiful and imposing structures will stand for centuries. The Queensboro Bridge is a stunning example of the spirit of this age.

Separating the islands of Manhattan and Long Island is the East River, a tidal strait. As New York and its sister city Brooklyn expanded and prospered, it was a barrier that challenged entrepreneurs, politicians, and visionaries. In time, eight bridges were constructed. The lower four—the Brooklyn, the Williamsburg, the Queensboro, and the Manhattan—were built by 1910.

As early as 1867 two companies, one in Queens the other in Brooklyn, received New York State charters to proceed with construction of spans across the East River. Both were organized by the wealthy and influential in their respective areas. At that time Queens's economic activity was largely centered on agriculture. Large tracks of woods and open farmland surrounded a number of small towns and villages. The New York and Long Island Company, based in Long Island City, strove for many years to keep the company viable but the obstacles proved formidable, construction ceased, and the firm declared bankruptcy in 1895. However, the Brooklyn Bridge Company, based in a more populous and prosperous location, captured the interest and attention of New York City's government and in 1883 the beautiful Brooklyn Bridge celebrated its grand opening.

Following the success of the Brooklyn Bridge, city leaders and the public enthusiastically focused their attention on a bridge span joining midtown Manhattan and Queens. In Long Island City, the Committee of Forty was formed to lobby for a bridge to Queens. Although earlier attempts had failed, this time they were determined to succeed.

In 1898, drawn in part by promises of improvements to public transportation, Queens and Brooklyn agreed to consolidate within the five-county Greater New York. The following year the board of aldermen voted to fund the initial construction phase. Immediately a flurry of contracts and appropriations were issued to those with political connections.

Plans for a cantilever bridge were selected because it was economical to build, was stronger than a suspension bridge, and allowed for very long spans with wide clearances beneath the road

deck. This type of bridge also took advantage of the Blackwell's Island location in midstream. The construction is similar to a diving board, with the cantilever span analogous to the end of the board extending over the water. This type of bridge also took advantage of the Blackwell's Island (now known as Roosevelt Island) location, a two-mile outcropping of rock located midstream between Manhattan and Queens.

The bridge had a short truss span over Blackwell's Island and two long spans of uneven length reaching out over both channels on the East River. These cantilever spans consisted of a chain of pin-linked eyebars (with diagonal and vertical stiffeners beneath them). These arms were met by another two cantilever spans anchored in two anchor towers onshore in Manhattan and Queens.

In 1902, the mayor of New York appointed Gustav Lindenthal as commissioner of the new department of bridges. Lindenthal envisioned a design that fused engineering and art, stating, "In a bridge it is not possible to separate the architectural from the engineering features." Working with other engineers, he proposed the now-familiar twin cantilever design with two spans connected by a smaller span over Roosevelt Island (then known as Blackwell's Island), a two-mile outcropping of rock located mid-channel between Manhattan and Queens. The bridge was to be put together with nickel-steel, a new alloy, and eyebars instead of cable.

Seven years later, beleaguered by conflicts and delays, the Queensboro Bridge was finally completed. In March 1909, it was thrown open to the public. Three months later, in mid-June, there was a grand ceremonial opening. The span had an immediate and profound effect on the development of Queens.

Two millstones from a tidal mill from nearby Burger's Sluice, a millpond at vanished Dutch Kills, remain embedded in the concrete of Queens Plaza. Dating from the 1640s, they are believed to be the oldest European artifacts in Queens and may have arrived in America as ballast in a Dutch merchant ship. (Courtesy of Steven Melnick collection.)

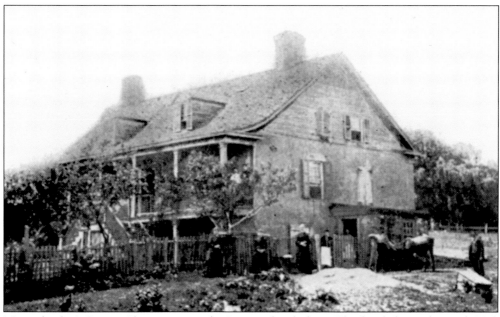

Most of today's Queens Plaza was once the Payntar family farm. The family home (around 1720) was just off Queens Plaza between Northern Boulevard and the Sunnyside rail yards. It was torn down in 1912, three years after the bridge opened. (Courtesy of GAHS collection.)

The Boston Post Road (between New York and Boston with a branch to Albany) ran under what would later be the bridge pier at Second Avenue. Begun in 1795 by Col. William Smith, the Mount Vernon Hotel (Abigail Adams-Smith) Museum still sits in the shadow of the Queensboro Bridge on East 61st Street. This former carriage house, and later hotel, was built when the city was no farther north than Greenwich Village. (Courtesy of GAHS collection.)

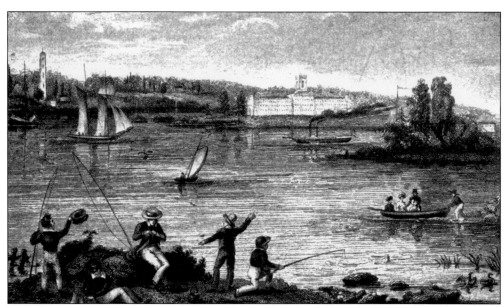

Titled *Uncle Phillip's Fishing Party*, a day angling in Greenpoint at Newtown Creek and the East River is remembered in this sketch from about 1830. The Youle Shot Tower, to the left, stood until 1907 near 54th Street in Manhattan. The building in the center is on Blackwell's (Roosevelt) Island. To the right, the Hunter farm is at Hunters Point, Long Island City, Queens. (Courtesy of GAHS collection.)

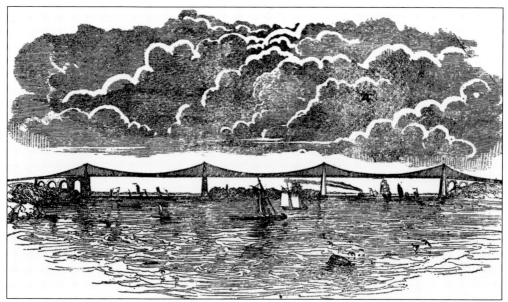

In 1838, a few years after Uncle Philip and his fishing party, *Family Magazine* published the "Grave's Plan" for an iron hanging bridge over the East River. The article stated, "We hope in the course of a few years, to have the pleasure of walking over this bridge which if erected, will be highly honorable to the country and to all concerned." (Courtesy of GAHS collection.)

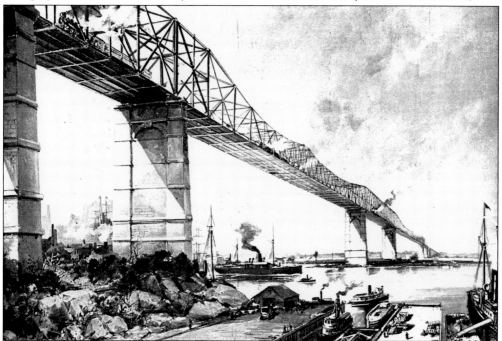

The first serious attempt to link Queens and Manhattan, the New York and Long Island Bridge Company incorporated on April 16, 1867. The city purchased land for bridge piers at East 77th Street on the East River (John Jay Park in Manhattan) and in Queens, at the foot of 34th Avenue (Rainey Park). Despite a promising start, the project languished after a series of financial panics in the 1870s. (Courtesy of GAHS collection.)

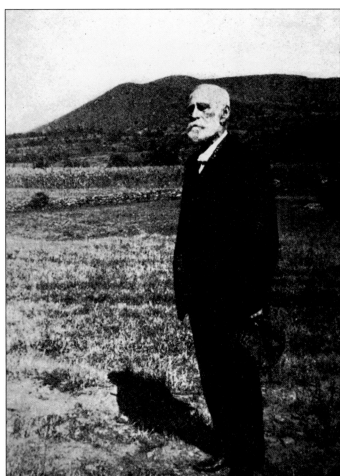

Dr. Thomas C. Rainey was called "the father of the bridge." For nearly 40 years he battled lack of funds, municipal indifference, and economic downturns to achieve his goal. Dr. Rainey did live to see a bridge built across the East River to Queens in his lifetime. On the East River in Ravenswood is a park that bears his name. It was to be the Queens pier for his bridge. (Courtesy of GAHS collection.)

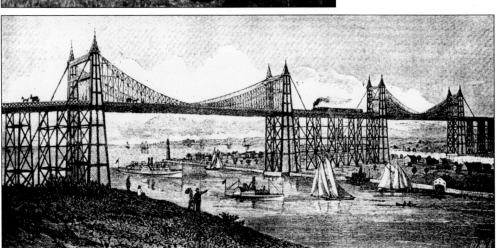

Work for the bridge, under Rainey's guidance, began in 1881 with sinking a caisson in Ravenswood. This steel engraving shows the structure as it was then planned, complete with railroad tracks. For a variety of financial and political reasons, the project again died. (Courtesy of Vincent Seyfried collection.)

The Long Island Railroad, which wanted to build a terminal in Manhattan, started a second effort. This plan suggested a steel cantilever structure that was to be 135 feet above high water and was to cost $7.5 million. The bridge was to have four rail tracks and space for pedestrians, as well as lanes for horse-drawn carriages and wagons. (Courtesy of GAHS collection.)

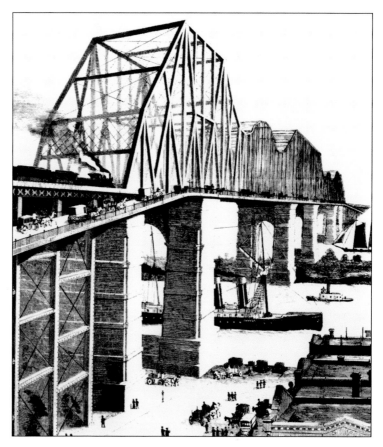

The railroad suggested a station for Manhattan near 64th Street and Third Avenue. Branches went to Morrisania in the Bronx, Grand Central Station, and the New York Central lines on the Hudson. Across the bridge on Long Island, it branched again. One track was proposed for the Brooklyn Navy Yard and another to the Long Island Railroad at Winfield junction, Queens. Work began in 1893, and footings for piers were built on Blackwell's (Roosevelt) Island. The project stalled again. (Courtesy of GAHS collection.)

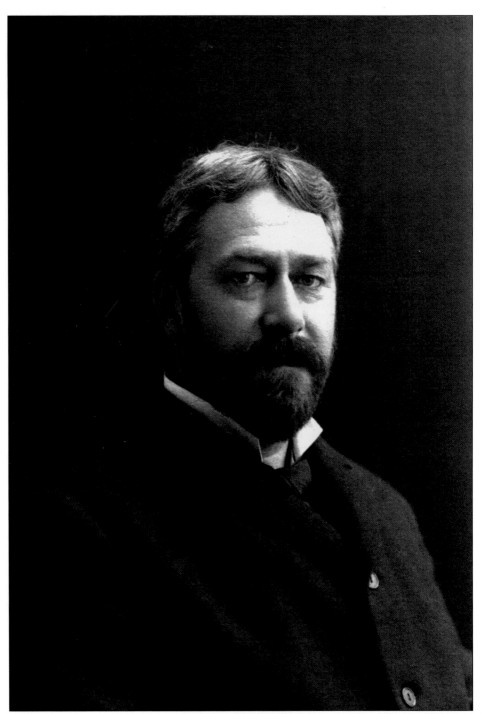

After the Committee of Forty breathed new life into the idea, a reform administration made Austrian Gustav Lindenthal the first commissioner of bridges for New York in 1902. Lindenthal, who found fame and fortune in Pittsburgh designing railroad bridges for the Pennsylvania Railroad, was an inspired choice to design the final version. A critic noted, "His designs were characterized by originality and boldness." (Courtesy of Allan Renz.)

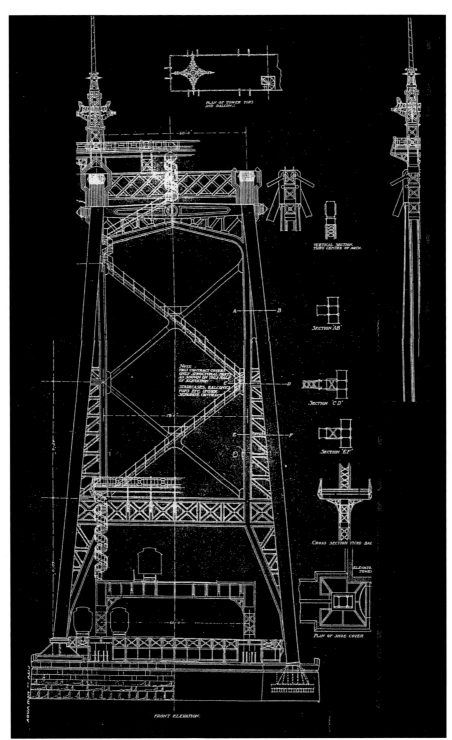

In this original architectural rendering of a bridge tower, note the spiral staircases leading from the upper pedestrian level to the top spire. A worker would climb them to run flags up both poles on each of the four piers. The staircases were later removed. (Courtesy of RIHS collection.)

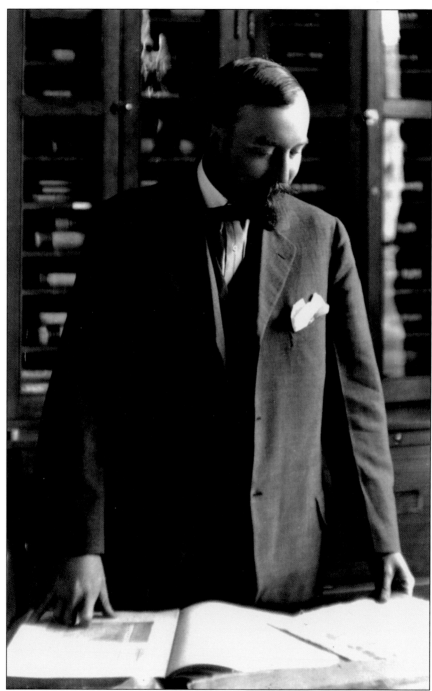

Brooklyn-born Henry Hornbostel, trained at Columbia University and in France, spent most of his career in Pittsburgh designing notable buildings, including the campus for Carnegie Mellon University. Living well into his 90s, this master draftsman designed more than 225 structures, including the campuses for Emory and Northwestern Universities. An impressive 22 buildings from his résumé are listed on the National Register of Historical Places. (Courtesy of Carnegie Mellon University Archives.)

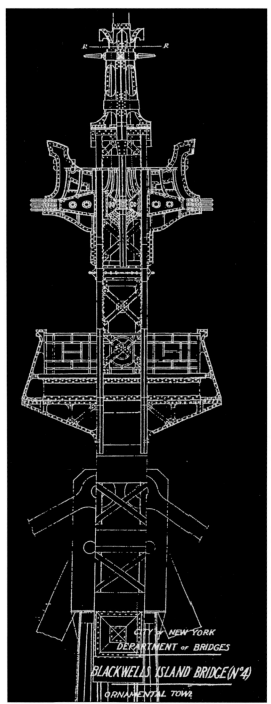

Original drawings of the flagpole holder for the bridge pinnacle show Hornbostel's attention to design. The middle portions resemble the prows of a Mediterranean trireme, a ramming warship from antiquity. Note that architect Henry Hornbostel worked his initials into the railings. The flags stopped flying in the 1940s. The finial flagpoles were removed in 1960 (see page 123). (Courtesy of RIHS collection.)

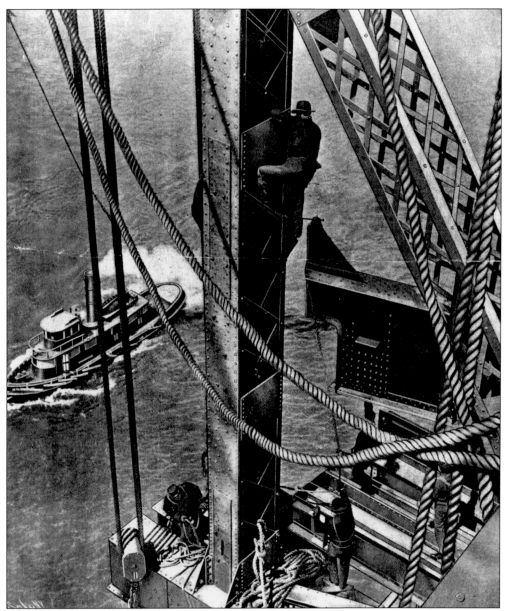

On a front cover of *Scientific American* from August 10, 1907, a worker stands on a spire of the bridge 160 feet above the water and more than 500 feet out on a cantilever arm. A portion of the bridge floor swings into place high above traffic on the East River. (Courtesy of Stephen Leone collection.)

Two

BUILDING THE BRIDGE

In 1902, after Mayor Seth Low appointed Gustav Lindenthal commissioner, Lindenthal's first act was to review plans for the Blackwell's Island Bridge. He concluded that the designs revealed an ugly bridge unfit for such a grand purpose. Lindenthal hired Henry Hornbostel, a respected architect, to work as chief assistant to remodel and enhance the existing design. The Queensboro Bridge owes its beauty to their collaborative geniuses. By training and inclination they worked well together.

The Lindenthal-Hornbostel design retained the original cantilever structure but narrowed it by 80 feet while maximizing the carrying capacity by adding an extra deck. The bridge was to accommodate four rail and trolley lanes, two vehicular roadways, and two walkways. Passengers reached the trolleys by one of a series of staircases beneath the roadway. Their entrances were protected by ornamented kiosks. Elevators were added to carry passengers and freight to both Vernon Boulevard and the so-called upside-down elevator storehouse on Blackwell's Island.

Four 350-foot steel towers were adorned with ornamental spires and rested on massive stone piers. The Manhattan and Queens masonry anchoring piers were designed not only to support the bridge but also to provide areas under the arches to be used for public purposes, perhaps markets. On the Manhattan side, a great public space was lined with beautiful Guastavino tiles.

The two long spans were redesigned to curve gracefully over the roadway of the massive structure. To further enhance its beauty, small architectural details were worked into and throughout the design. On the Manhattan approach, two 18-foot-high bronze lanterns flanked the entrance.

This new Beaux-Arts rendering ignited an immediate uproar of criticism and opposition. The Committee of Forty was especially vociferous. Fortunately for posterity, Lindenthal was able to rally support from the Municipal Art Society and other prominent citizens. Later, despite the premature departure of Lindenthal from the project, these groups were instrumental in preserving much of the Hornbostel design.

In 1903, after new plans were approved, problems continued to haunt the project. Lindenthal was dismissed when George B. McClellan became mayor of New York City. The United Pennsylvania Steel Company held the contract to fabricate and assemble the superstructure, and rumors persisted on less-than-satisfactory work. A prolonged steel strike delayed delivery of materials. The project was open shop—some disgruntled union workers attempted to blow up one of the spans. Even nature was unkind. While being hoisted into place during a violent windstorm, a span fell into the East River, fortunately missing shipping.

To further complicate matters, in 1907, a similar cantilever bridge under construction in Quebec, Canada, collapsed under its own weight, killing 75 workers. The safety of the cantilever design was questioned. Investigation followed investigation until two independent consultants determined the design sound. However, they did report the construction company had attached unauthorized beams to the structure. Again there was another delay as the dangerous overload of steel was removed and other tests undertaken to ensure the strength of the bridge.

On March 30, 1909, the bridge was finally opened to the general public. It had cost $20 million and the lives of 50 workers.

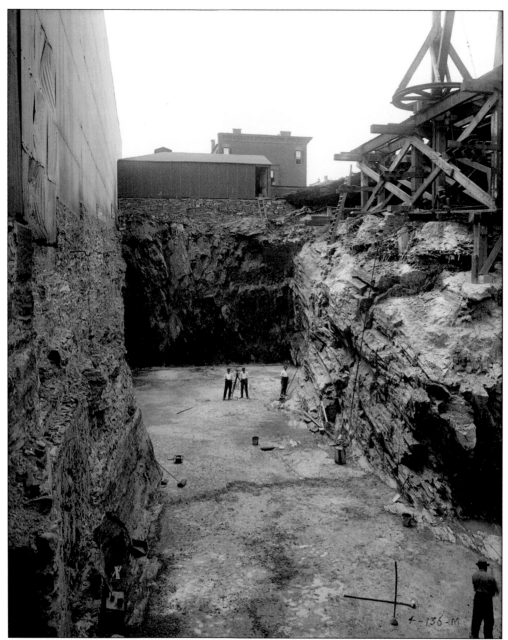

After the former buildings were removed, engineers had to blast down through 50 feet of solid bedrock in Manhattan and Queens to anchor the bridge. This rare image shows the excavation for the Manhattan pier at 59th Street. The bull wheel of a massive stone derrick, custom built for each job, stands ready at the right. (Courtesy of New York City Municipal Archives; photograph by Eugene de Salignac.)

Workmen tear down a building in the path of the bridge while families still live on either side. Five workers can be seen handing rafters down floor by floor from the roof. A partially completed Manhattan anchorage tower is in the back. The photographer is looking west at York Avenue and 60th Street. (Courtesy of Queens Chamber of Commerce collection.)

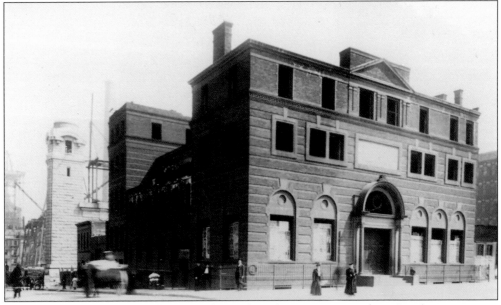

In March 1901, the board of aldermen authorized condemnation proceedings. Land acquisition, at nearly $5 million, was almost a third of the original estimated cost of $17 million. In Manhattan, the bridge replaced tenements and small factories. This is the view of First Avenue and 60th Street looking southeast. The Manhattan anchor pier is already built mid-block. (Courtesy of Queens Chamber of Commerce collection.)

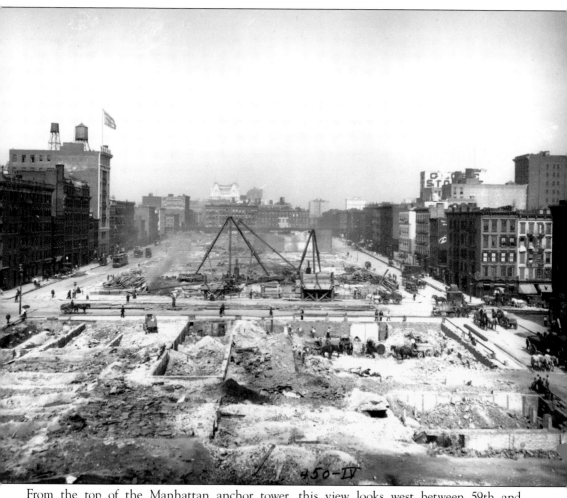

From the top of the Manhattan anchor tower, this view looks west between 59th and 60th Streets with buildings in the bridge's footprint demolished. In the distance is Second Avenue with elevated trains and a large advertisement for Bloomingdales painted on a wall. The Plaza Hotel with its two peaked roofs is in the background. Two steam-driven stone derricks are in the foreground. (Courtesy of New-York Historical Society collection.)

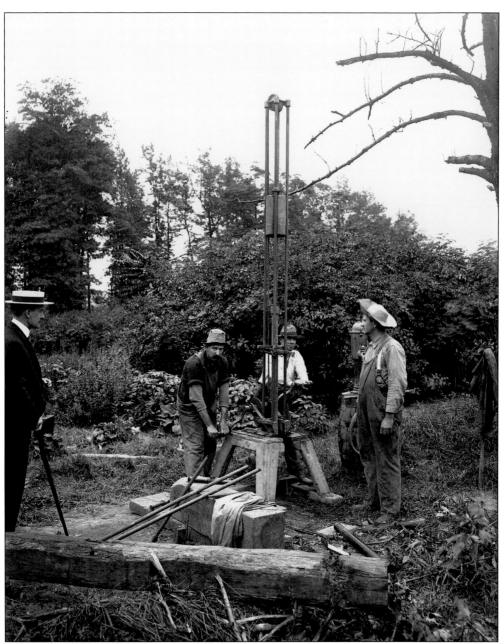

Most of the bridge approach in Queens went through Ravenswood Park, an undeveloped marshy area that was the headwaters for Sunswick Creek. Engineers had to cut their way through the undergrowth to survey the bridge footprint. Eugene de Salignac, the official bridge photographer, shows a pile driver taking a soil test boring at the east corner of Queens Plaza. (Courtesy of New York City Municipal Archives; photograph by Eugene de Salignac.)

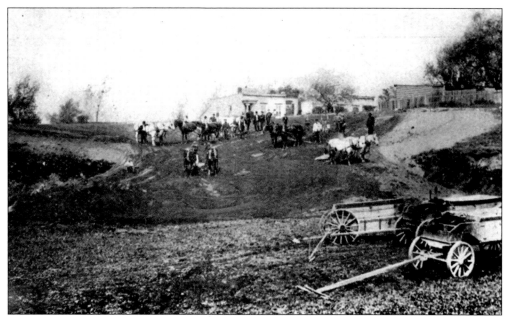

Crescent Street was a major street running north and south that started at Astoria Boulevard and ran to Hunters Point, a few blocks south of the bridge. Horse teams grade and fill in the land at the future Queens Plaza. Crescent Street remains an important southbound feeder street leading traffic to the bridge's lower level. See pages 90 and 91 for a later view. (Courtesy of GAHS collection.)

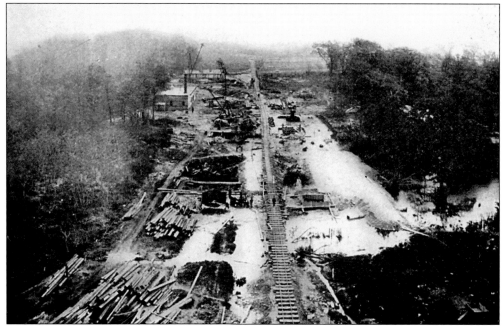

Facing west toward Manhattan, the footprint for the future bridge in 1907 was a wooded muddy construction site. Ravenswood Park was one of the last large undeveloped properties near the East River. Within two years this space would be the bridge approach and a grandly landscaped entrance to Queens Plaza. (Courtesy of GAHS collection.)

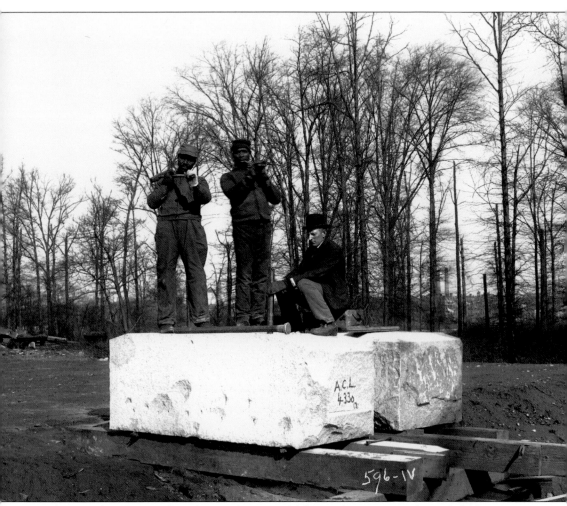

Photographer Eugene de Salignac shows two African American workers, sledgehammers on their shoulders, ready to trim one of the massive granite blocks. The other man is holding a chisel. Dressed elegantly in a bowler hat, white shirt, and necktie, he is perhaps a master mason. The pedestal blocks were transported on wooden skids. (Courtesy of New York City Municipal Archives; photograph by Eugene de Salignac.)

Contracts for the six masonry piers were awarded in June 1901, the year that is inscribed on a cornerstone in the base of the west Roosevelt Island pier. Work started in Manhattan the following month. Stone derricks swing blocks into position from the carefully stacked pile to the left. See page 121 for a modern picture of the cornerstone. (Courtesy of Vincent Seyfried collection.)

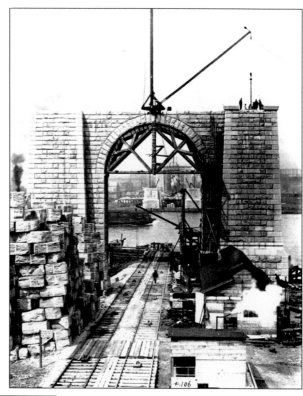

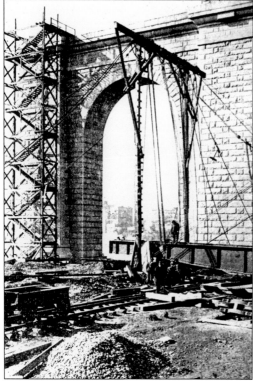

The secretary of war, who had to approve all bridges on the East River, mandated that bridge decks had to be at least 130 feet above water level, ensuring that masts of naval vessels at nearby Brooklyn Navy Yard could clear the ironwork. The piers, cement belowground, were limestone with granite facing. The stonework cost more than $858,000, well over budget. (Courtesy of GAHS collection.)

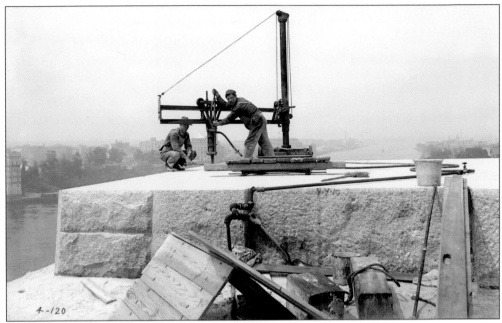

The notes of city photographer Eugene de Salignac, who officially documented the project, explained that this was the stone-trimming machine on top of pier No. 2 (the western Roosevelt Island tower). Two workers smooth the pier's top in preparation for the ironwork pedestals. The machine is driven by compressed air. Note the lack of scaffolding or safety equipment to protect them from the 130-foot drop. (Courtesy of New York City Municipal Archives; photograph by Eugene de Salignac.)

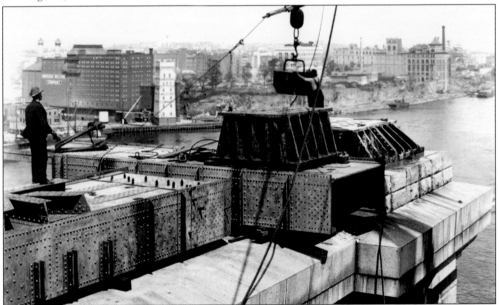

Steel pedestals were placed upon the completed stonework. They were composed of three courses of steel castings and weighed 140 tons. The pedestals had to be strong to support several 5-foot-by-19-foot tower post sections, each weighing 126,000 pounds. (Courtesy of Queens Chamber of Commerce collection.)

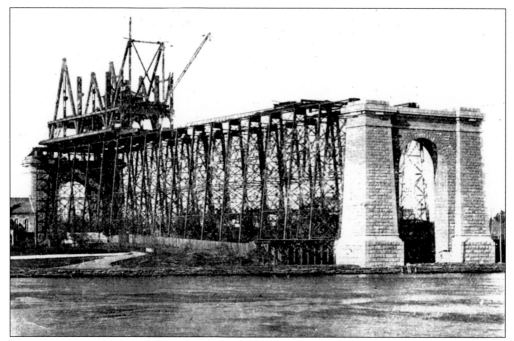

The truss span on Roosevelt Island and its two anchor spans were too heavy for timber falsework, which is the temporary structure built under the bridge to support the roadbed. The Queensboro Bridge made the first use of steel falsework, a latticework of plate girders that was built upon a special foundation. It weighed 1,700 tons. (Courtesy of GAHS collection.)

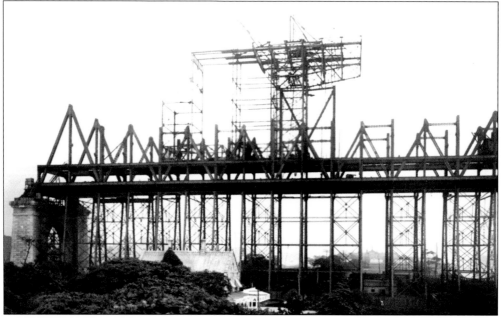

On November 20, 1903, the United Pennsylvania Steel Company was awarded the $5.1 million construction contract for the steel superstructure. The central span on Roosevelt Island and its two adjoining spans (crossing the east and west channels of the East River) weigh 54,200 tons. (Courtesy of GAHS collection.)

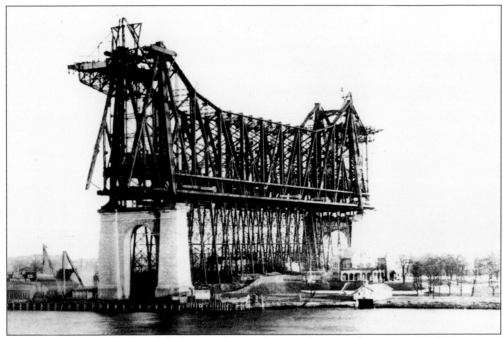

The falsework construction of the Roosevelt Island section began in September 1904. The actual work on the bridge itself did not begin until the following August. The Queensboro Bridge is a double-cantilever truss bridge. The central truss section anchors the two cantilever arms that reach out across the East River channels. (Courtesy of Museum of the City of New York.)

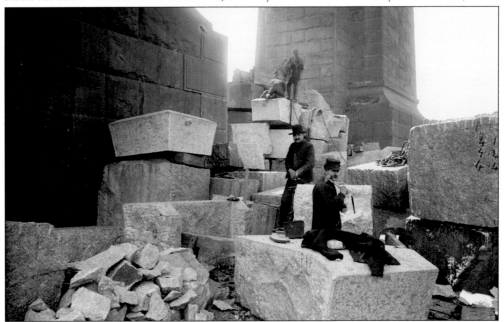

Bridge photographer Eugene de Salignac posed workers on a stone pile on Blackwell's Island. Gigantic piers and massive stone blocks dwarf the men. Nearly 150,000 cubic yards of stone masonry were used. (Courtesy of New York City Municipal Archives; photograph by Eugene de Salignac.)

To hang the road deck and carry the weight of traffic, Gustav Lindenthal preferred nickel-steel eyebars on a cantilever bridge instead of suspension bridges and their wire cables. Eyebars took longer to install but were more economical. They built a stronger bridge within a smaller footprint. Workers step out on eyebars awaiting new sections of roadway to be swung into place from the overhead traveling crane. (Courtesy of GAHS collection.)

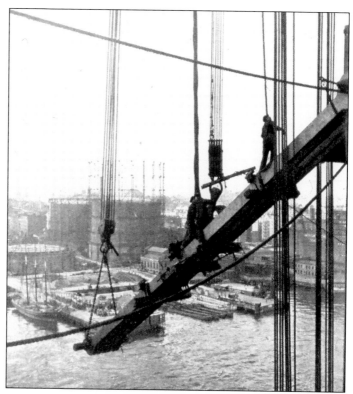

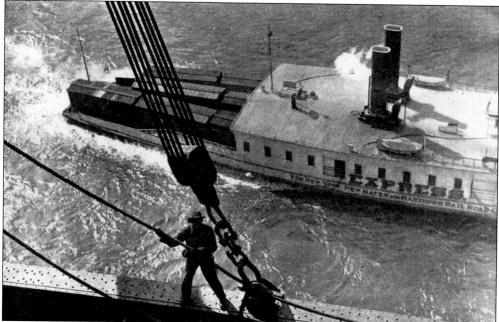

One of the bridge gang is standing on a floor beam that has just been swung out into position. The size of the individual pieces of steel was so great (pieces weighed up to 60 tons) that specially designed hoists, derricks, travelers, and machinery were needed. The East River ferryboats gave the best views of construction. (Courtesy of Stephen Leone collection.)

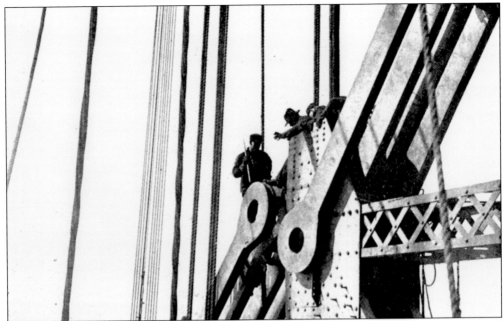

Unlike suspension bridges, the cantilever bridge is built like a giant Erector set. Pieces are fitted together and held in place by familiar bolts and nuts, but done on an enormous scale. A group of workers assemble eyebars at the intersection of a vertical post and diagonal. The group is ready for pinning, or driving in the steel pin connecting a new segment. (Courtesy of Stephen Leone collection.)

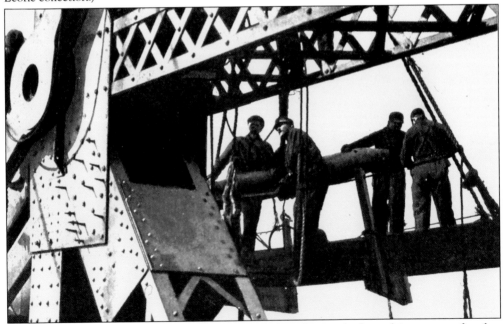

As soon as everything was in line, a 14-inch nickel-steel pin, which in this case was five feet long, is swung into position. The largest pins were twice this length and weighed more than 7,000 pounds. The number of eyebars gradually decreased from the top chords (20) down to the bottom chords (only four ribs). (Courtesy of Stephen Leone collection.)

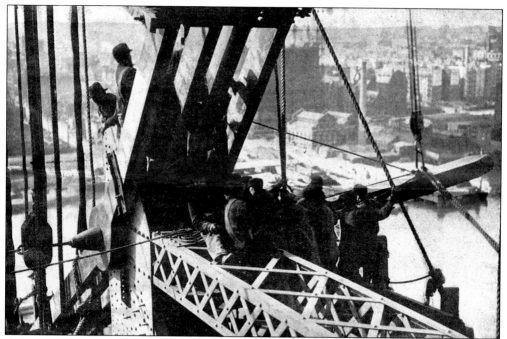

A five-ton swinging ram drives the pin into place. To guide it through the eyebars and posts, the front end is temporarily furnished with a false conical head screwed on. After the pin is driven home, the head is removed, and the large nut that keeps the pin permanently in position is screwed into place. (Courtesy of Stephen Leone collection.)

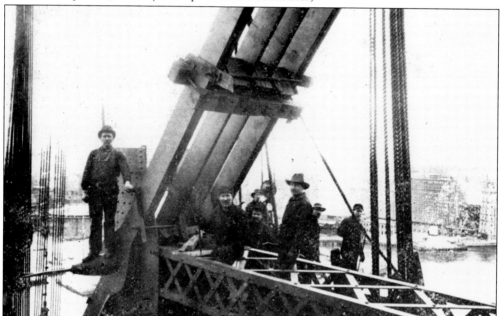

With the process finished, the work gang poses for a photograph. They are about to begin the cycle again, guiding the heavy bridge members into position and then connecting them by large pins at various panel points. The greatest amount of steel bolted to the bridge in one eight-hour workday was 512 tons. (Courtesy of Stephen Leone collection.)

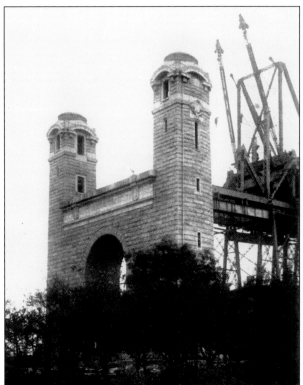

The anchor castings are buried in two towers in Queens and Manhattan. The Queens tower, pictured, not only contained ventilation shafts but also a staircase and an elevator shaft for access to the street. The last sections of the bridge built connected these towers with the approach ramps. (Courtesy of GAHS collection.)

The Queensboro Bridge is a cantilever design. The road deck weight creates tension on the arm as it extends outward over the east and west channels of the river. These arms are held in place by a chain of eyebars that are connected to an anchor casting and anchor bolt embedded in both the Manhattan and the Queens anchor towers. (Courtesy of GAHS collection.)

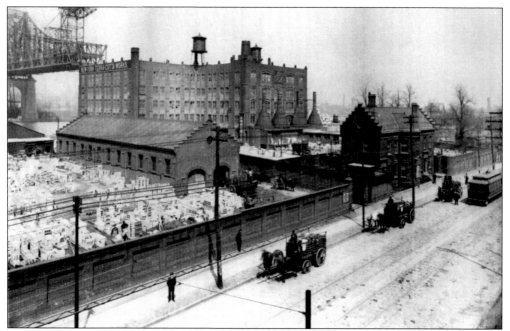

This photograph shows the progress between the east Roosevelt Island pier and the Queens pier (behind the factory). In the foreground is the New York Architectural Terra Cotta Works on Vernon Boulevard in Queens. The cantilever arm, anchored at one end by the island truss span, extends 984 feet over the east channel of the East River. (Courtesy of GAHS collection.)

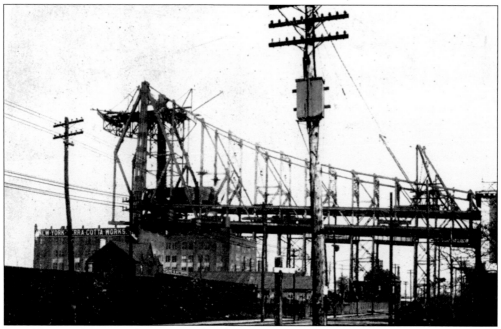

Dated January 30, 1908, the major steelwork on the bridge was nearing completion. The Queens anchor arm, between the Queens anchor tower (right) and the Queens pier (left), at 459 feet, was ready to stretch out an arm over the East River's east channel toward the central span. The New York Architectural Terra Cotta Works is in the center. (Courtesy of GAHS collection.)

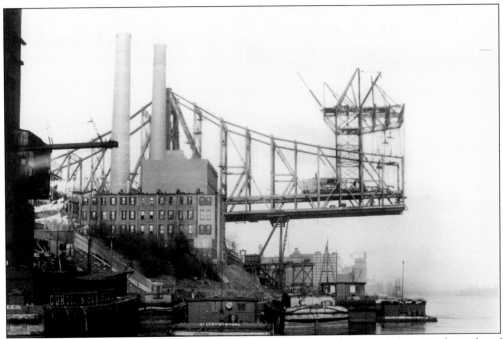

The Manhattan anchor arm, to the left of the Manhattan pier, was 496 feet. To the right of the pier, the cantilever span over the East River's west channel was the longest segment at 1,182 feet. The total length of the bridge, from anchor tower to anchor tower, was 3,724 feet. (Courtesy of GAHS collection.)

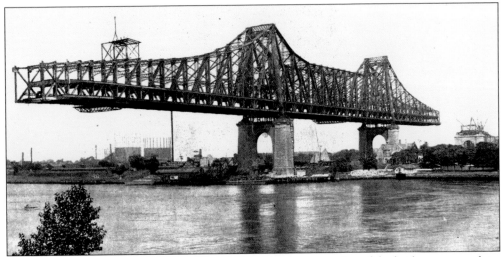

By August 1907, after two years of steelwork, the central truss portion of the bridge was complete. With the cantilever spans extended out over the East River, the falsework was removed from under the Roosevelt Island span. Connections to the Manhattan and Queens anchor spans, and the two approaches (linking Second Avenue in Manhattan and Jackson Avenue in Queens), took another year and a half. (Courtesy of GAHS collection.)

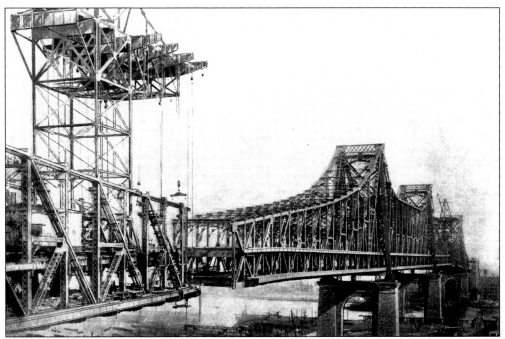

A Z-shaped traveling crane, called a traveler, was used for handling and placing the steelwork. The upper arm projects over the work area, and the lower arm reaches far back into the span where it is counterweighted or bolted down to the completed cantilever section. The traveler weighed 500 tons and was capable of handling a load of 70 tons. (Courtesy of GAHS collection.)

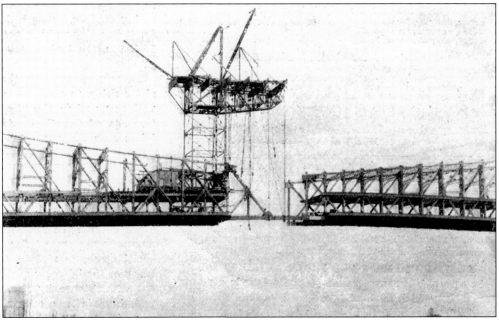

Provision for slight bridge movements due to shifting temperature or loads was made at the center where the two channel spans met at mid-river. There a hinged rocker connects the two cantilever arms. This rocker is pin-connected to the bottom of one span and to the top of the other. (Courtesy of GAHS collection.)

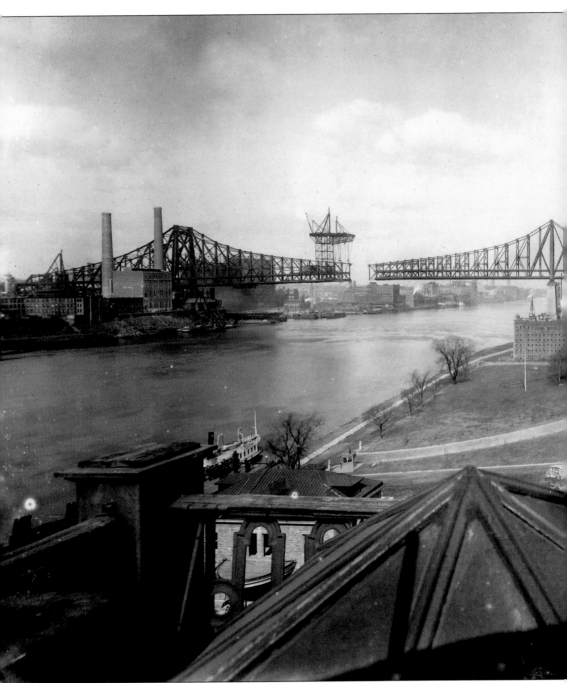

This panorama shows the traveling cranes in position ready to lift the final sections of the roadway. The view is from the roof of City Hospital on Blackwell's Island. The building to the north of the hospital is the penitentiary. It is perhaps the best picture taken showing the

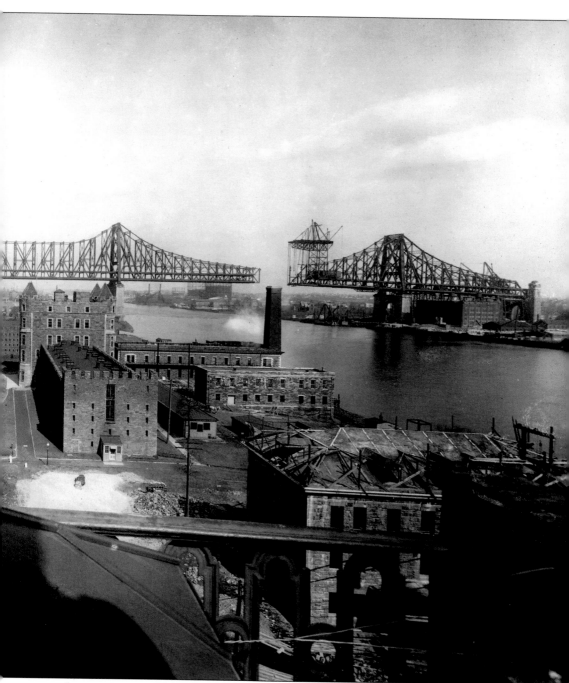

sweep of construction on the bridge, all 3,724 feet of it, from anchor tower to anchor tower. The total project, including bridge approaches and Queens Plaza, is 8,601 feet, more than twice the distance covered by this photograph. (Courtesy of New-York Historical Society collection.)

Well into the 20th century, large civic projects relied on muscle from steam engines and real horsepower. The bridge is dimly seen in the distance. The frame for a pedestrian walkway rises at Queens Plaza. The pedestrian footwalks rose at a gentle 3.5 percent slope to tower 165 feet above high water at mid-span. For a completed view see page 90. (Courtesy of GAHS collection.)

Workers were native and immigrant, white, black, and American Indian. Bridgework always had an element of danger. This broken derrick killed a worker at Ely Avenue (23rd Street) in Queens. Fifty workers were killed on this project. Hundreds more were injured—all before the era of workers' compensation and disability insurance. (Courtesy of GAHS collection.)

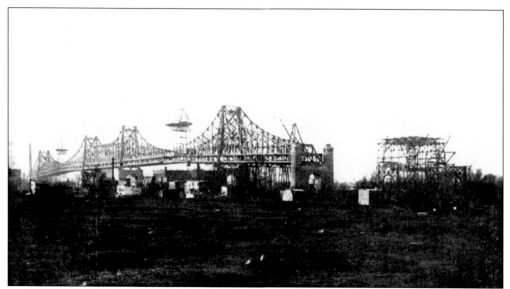

In 1908, work started on the last segment of the bridge, the Queens approach. At 2,672 feet, it alone dwarfed the three longest suspension bridge spans of that time, the Brooklyn Bridge (1,595 feet), the Williamsburg Bridge (1,600 feet), and the Manhattan Bridge (1,470 feet). (Courtesy of GAHS collection.)

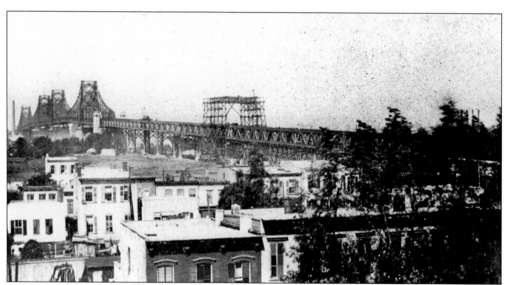

In February 1908, the city took title under eminent domain for the Queens approach and Queens Plaza. In July, the contract was issued for grading Queens Plaza. The last link in the Queens approach was joined on August 17, 1908. (Courtesy of GAHS collection.)

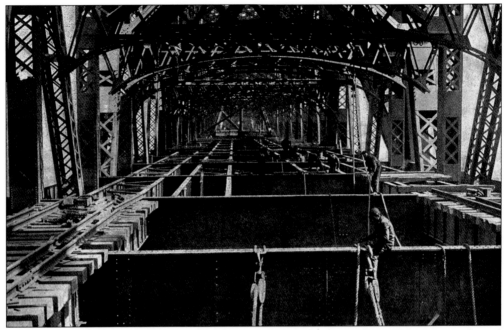

This is a view looking along the upper floor of the bridge showing the main trusses, lateral bracing, and floor beams. Floor beams were 55 feet long, and the largest weighed 36,000 pounds. The rail tracks in this picture are from the traveler used in erecting the span. (Courtesy of GAHS collection.)

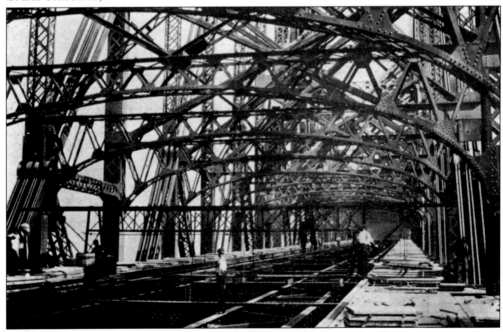

Under a latticework of beams, men are laying the pedestrian sidewalk on the upper deck. Originally four sets of rail tracks were to be placed on the upper level, but concerns about the weight of elevated trains caused the design to be changed to only two tracks. Walkways were then brought inside the span. (Courtesy of GAHS collection.)

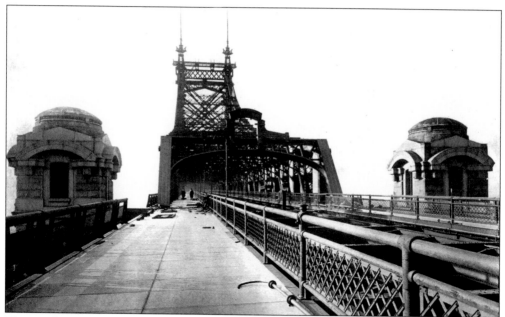

The small towers are the structures where the series of eyebars that hold up the spans are anchored into place. The dedication plaque niche is still empty, and scattered construction debris litters the upper walkway, but railings are installed. Crews were testing the bridge lights only two days before the March 30 opening. (Courtesy of GAHS collection.)

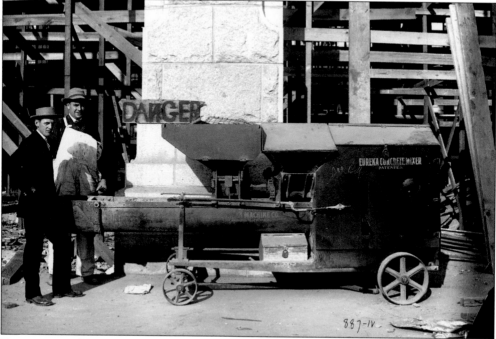

Two men stand beside an early cement mixer. Although equipment was primitive by today's standards, this generation was able to build monuments, like the Queensboro Bridge, that still awe and impress. Their workweek was long, and for them, safety equipment was an afterthought. (Courtesy of New York City Municipal Archives; photograph by Eugene de Salignac.)

After the buildings were removed along the right-of-way in Manhattan, temporary scaffolding, called falsework, was built under the 470-foot Manhattan anchor arm. It was needed until the roadway and bridge superstructure were connected. The Manhattan anchor tower is in the left foreground, and the Manhattan pier can be seen in the middle, almost hidden, behind the falsework. (Courtesy of GAHS collection.)

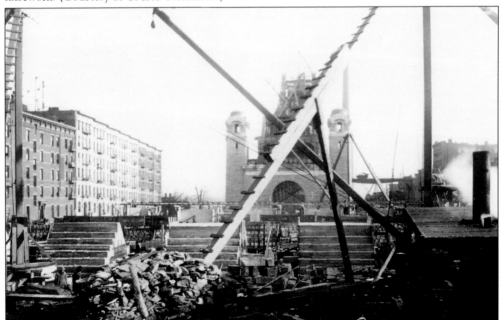

Crossed booms from steam-powered stone derricks frame the 1,000-foot approach to the Queensboro Bridge in Manhattan. The foreground would be decked over for the Manhattan trolley loop and the vehicular entrance to the bridge. (Courtesy of GAHS collection.)

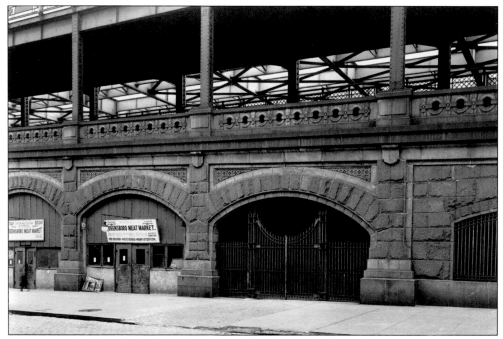

The suggestion that the bridge approach would make a superb market space was an excellent idea. On opening day, September 1, 1914, more than 100,000 people patronized farmers markets at the Queensboro Bridge and three other locations in Manhattan. The Queensboro Meat Market was near the First Avenue arch. This space was later used by the city department of transportation for offices and storage. (Courtesy of New York Transit Museum.)

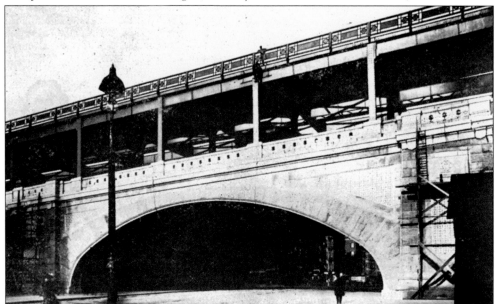

A beautiful vaulted arch of Guastavino tile marked the bridge crossing First Avenue. Famous for the patented tile vaulting system, the Guastavino Fireproof Construction Company installed its unique vaulting system in more than 1,000 buildings in the United States and abroad. (Courtesy of GAHS collection.)

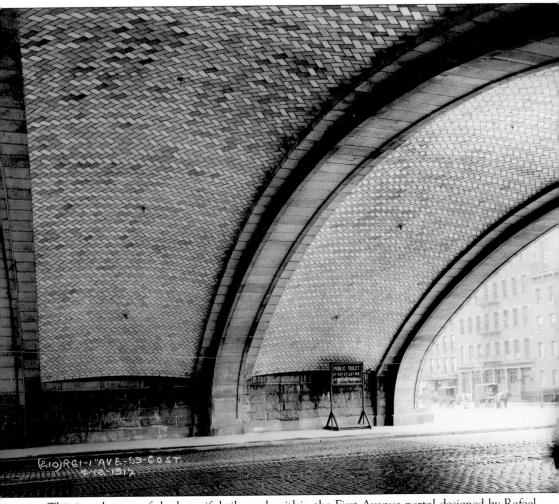

This is a close-up of the beautiful tile work within the First Avenue portal designed by Rafael Guastavino. He studied architecture in Barcelona, Spain, where he established a reputation for fireproof construction and built factories, warehouses, and apartment houses. In 1881, he settled in New York City. Henry Hornbostel used Guastavino tiles in a number of his buildings. The photograph dates from 1919. (Courtesy of New York Transit Museum.)

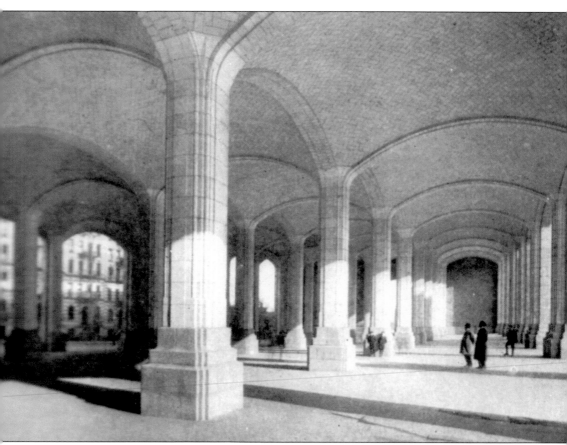

A bridge market flourished under the Manhattan approach from 1914 until the 1930s. Gustav Lindenthal incorporated a beautiful space with arches of Guastavino ceiling tiles. This view, toward 60th Street east from Second Avenue, shows the space to good effect. After being used as a storage area for decades, its splendor was restored and since 1999 it is again a market. (Courtesy of GAHS collection.)

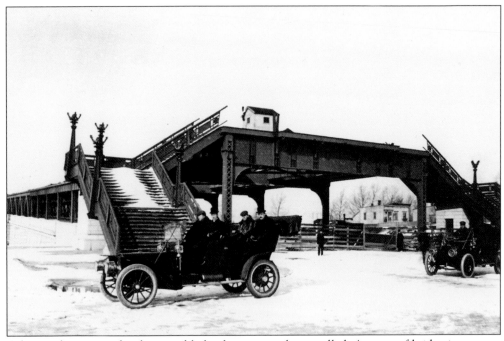

A barricade is up, and railings and lights have yet to be installed. A party of bridge inspectors examines the work on a wintry day in Queens, just weeks before the bridge opening. Their work was never completed. The constant, ever-changing demands from traffic forced the city to repeatedly reconfigure the roadways and exit ramps, thus insuring that the bridge will always be a work in progress. (Courtesy of GAHS collection.)

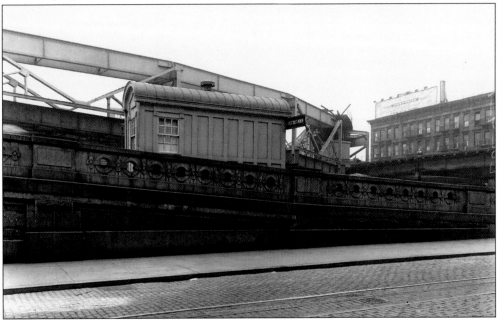

The women's comfort station was located on the bridge's pedestrian exit at 60th Street. The gents' room was on the 59th Street side. The ramp to the Second Avenue subway soars overhead. (Courtesy of New York Transit Museum.)

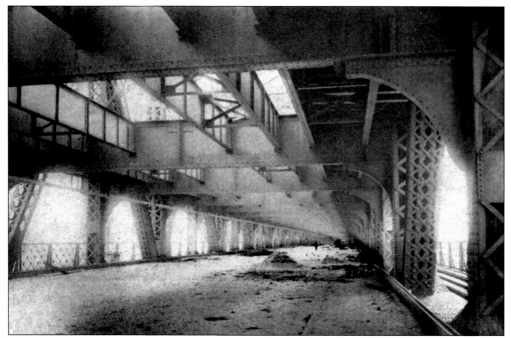

Both animal and automotive traffic made bridge maintenance a challenge. Within a few years the bridge was handling volume beyond its designed capacity. Only cold weather could put a halt to an endless series of bridge repaving. To offset concern over the strain from elevated trains on the upper level, a special lightweight roadway was installed. It was made of wood blocks set in concrete. (Courtesy of GAHS collection.)

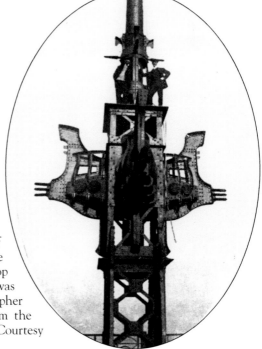

Two young men standing at the foot of the flagstaff are employees of the bridge department who, on a dare, climbed to the top of the pinnacle spire shortly after the bridge was completed. To take this picture, the photographer hauled his equipment hundreds of feet from the roadway to the top of the adjoining tower. (Courtesy of GAHS collection.)

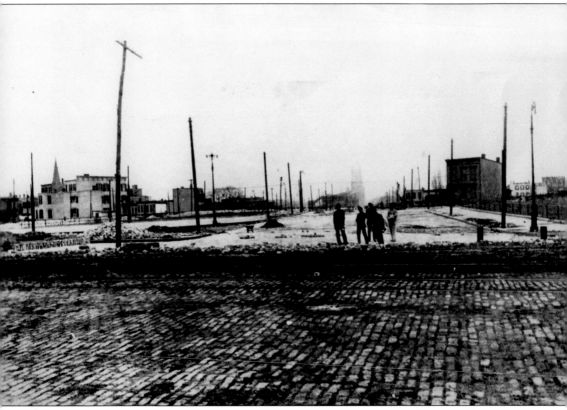

Taken in early March 1909, less than a month before opening the bridge to traffic, a group of workers complete the final blocks of pavement linking Jackson Avenue (Northern Boulevard) in the foreground with Bridge Plaza. The massive Queensboro Bridge is a distant shadow. (Courtesy of GAHS collection.)

Three

CELEBRATION

Finally the East River, long an obstacle to the development of Queens, was no longer a barrier. To commemorate this great achievement, a grand celebration was planned. This effort was sponsored by the Committee of Forty and organized by the Business Association of Long Island City. This group got together with others in Queens, Manhattan, and Brooklyn who had invested heavily in this project. They collectively called themselves the Committee of 125.

In April 1909, an elaborate luncheon was held at Bloomingdales Department Store, just one block from the Manhattan entrance to the bridge. Dignitaries from around the city attended. At the conclusion of this event, plans for the grand eight-day celebration scheduled to begin on June 12 were released to the press.

By the special day in Queens a reviewing stand and three enormous tents were erected. One tent was assigned to the Irish-American Athletic Association, another was used as a theater for nightly musical presentations, and the third housed a circus. Space was also provided for carousels and amusements to entertain the public.

Assembled for the parade on Saturday, June 12, were the National Guard of Brooklyn and New York, volunteer firemen, members of both the Democratic and Republican Societies, and 3,000 members of Tammany Hall. Following were thousands of schoolchildren riding on decorated wagons and floats, including a gigantic pâpier-maché whale, a gift from the people of Suffolk County. Other floats represented some of the commercial activities of New York, including pianos, meatpacking, silk, chewing gum, plumbing, and automobiles. Approximately 25,000 citizens of the city were participants.

Setting off sharply at 12:30 p.m., these massed groups made their way from 34th Street up Fifth Avenue to 59th Street and then across the Queensboro Bridge to Queens Plaza in Long Island City. As the parade passed the reviewing stand, the band played and 1,500 schoolgirls, dressed in red, white, and blue and arranged to represent the United States flag, sang "My Country 'Tis of Thee" and other patriotic songs. The multitude took hours to pass the reviewing stand, and then best-in-class rewards of trophies, flags, and other memorabilia were awarded. Finally, in the attendance of high-ranking city and state officials as well as other VIPs, the official ceremonial dedication turned the Queensboro Bridge over to the City of New York.

At 8:00 p.m. the speeches concluded and the fireworks show started. While other memories faded, few forgot the awesome two-hour spectacle that followed. The bridge was lit by hundreds of incandescent lights attached to its outer frame, and from below by the powerful searchlights that were fitted on the decks of ships and boats of every class as they bobbed in the East River. The illumination was so bright that the bridge appeared enveloped in flame. A crew of

40 explosives experts set about detonating fireworks off the deck of the bridge. The pyrotechnical display had the force equal to two tons of packed TNT.

Thousands applauded and yelled in delight as the cleverly crafted explosives drew pictures in the night sky. One represented a carnival of flowers in a basket resting on a golden cloth. Another depicted an immense octopus whose claws scraped the sky. Finally a multicolored Niagara Falls spilled off the south side of the Queensboro Bridge. Once the fireworks were over, several thousand people retired to Queens Plaza to watch the first performance of *The Mocking Bird*, a comic opera. As reported in the *New York Times*, over 300,000 people watched as Queens was linked to the "Old City." This was greater than the population of Queens County at that time.

The celebration continued for the next seven days; each day offered new entertainments. Included were the big baby parade with prizes awarded for the prettiest, smallest, cutest, and biggest child, and musical presentations by massed choruses of German and other fraternal associations. Athletic contests were held, including a 15-mile marathon race over and back on the bridge for amateur runners. There was even a scavenger hunt by automobile.

The celebration concluded with Mardi Gras Night. During intermission of the final presentation of *The Mocking Bird*, a young woman chosen as "Queen of the Bridge" was crowned. Across town, a baronial dinner was held at the Waldorf Astoria Hotel for 1,000 select guests. It was a fitting ceremony for this extraordinary public works project.

Anticipating the opening of the Queensboro Bridge, the elite Committee of 125 met in Long Island City to plan a celebration that would attract national interest. To sell the idea, a convention at Schuetzen Park was organized and hundreds of letters and tickets were posted to civic, fraternal, industrial, and commercial organizations asking for three delegates from each to attend. (Courtesy of Queens Borough Public Library collection, Long Island division.)

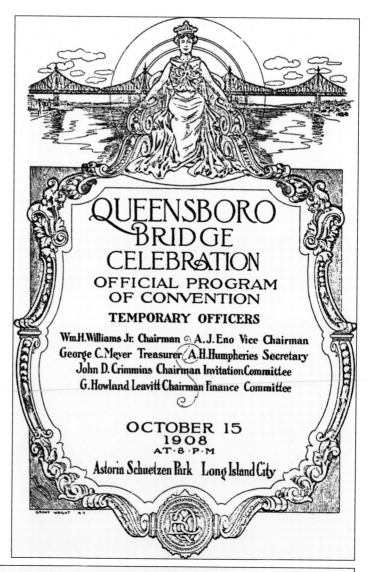

QUEENSBORO
BRIDGE
CELEBRATION
OFFICIAL PROGRAM
OF CONVENTION
TEMPORARY OFFICERS

Wm.H.Williams Jr. Chairman ❧ A.J.Eno Vice Chairman
George C.Meyer Treasurer ❧ A.H.Humpheries Secretary
John D. Crimmins Chairman Invitation Committee
G. Howland Leavitt Chairman Finance Committee

OCTOBER 15
1908
AT·8·P·M

Astoria Schuetzen Park Long Island City

Queensboro Bridge Celebration Convention

SCHUETZEN PARK HALL

Cor. Broadway and Steinway Avenue

Long Island City

Thursday Evening, October Fifteenth, 1908

EIGHT O'CLOCK

4700

Admit Bearer to Reserved Seats for Guests

4700

A near riot broke out on the evening of October 15, 1908, when an overflow crowd of several hundred was turned away from Schuetzen Park. Scores of local luminaries were appointed to a dizzying array of committees. The ticket pictured is one of the 6,000 issued. (Courtesy of Stephen Leone collection.)

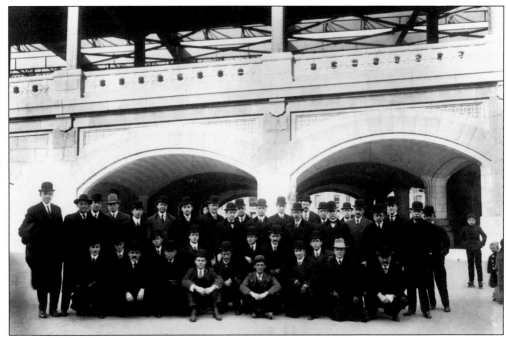

Posing for a group photograph in front of the bridge are the engineers who worked for the commissioner of bridges. It is believed that they are the group also pictured on page 61 leading the parade on Saturday, June 12, 1909. That day they and 30,000 other New Yorkers marched from 34th Street in Manhattan to Queens Plaza in what was called "the Great Land Parade." (Courtesy of GAHS collection.)

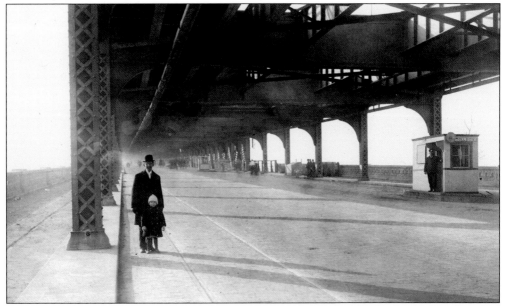

One of the bridge engineers and his daughter stand on the road under the bridge's steel trusses. Opposite them is the Queens tollbooth with the toll collector standing in the doorway. The toll, at 10¢, was abolished in 1911. This picture was perhaps taken early on the opening day in March. (Courtesy of GAHS collection.)

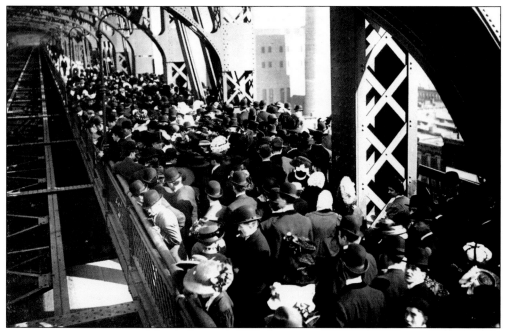

On March 30, 1909, the bridge was thrown open to the public. A crowd of people in their Sunday best, and numbering in the tens of thousands, packed itself onto the bridge walkway to experience the novelty of walking across the East River to Queens. (Courtesy of New York City Municipal Archives.)

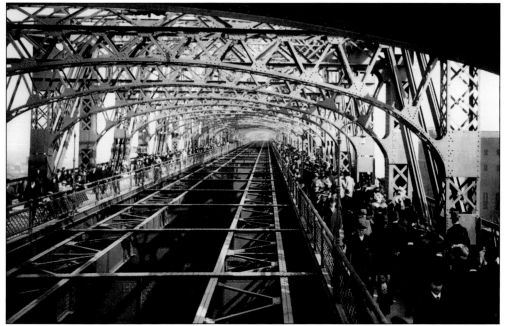

Originally there were pedestrian sidewalks on both sides of the upper deck. For a short time the bridge was the highest structure in the area. The center of the upper span remained empty of tracks. The Second Avenue elevated trains waited six years for a Queens destination to be built at Queensboro Plaza. (Courtesy of New York City Municipal Archives.)

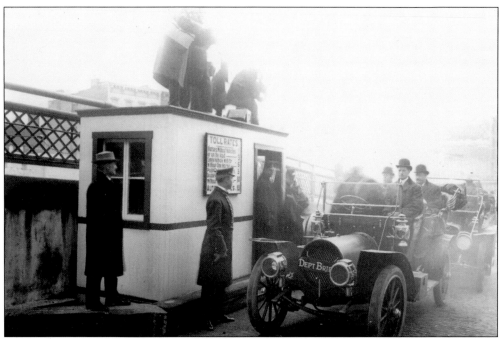

On opening day, Mayor George B. McClellan rides the first car across the bridge. Notice the photographers on the tollbooth. Although one of his predecessors, Mayor Robert Van Wyck, authorized the project in 1900, McClellan (son of the Civil War general of the same name) helped bring about the bridge's name change from Blackwell's Island Bridge to Queensboro Bridge. Irish groups opposed the Queensboro name. (Courtesy of GAHS collection.)

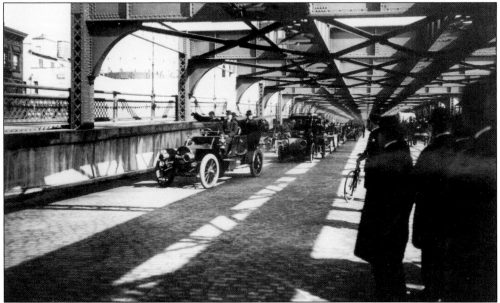

A crowd of spectators marks the mayor's progress. Acting mayor Sullivan actually led the first official party across the bridge a year earlier after the spans met on March 18, 1908. On St. Patrick's Day, March 17, 1909, the Ancient Order of Hibernians was the first group to officially cross the bridge. (Courtesy of GAHS collection.)

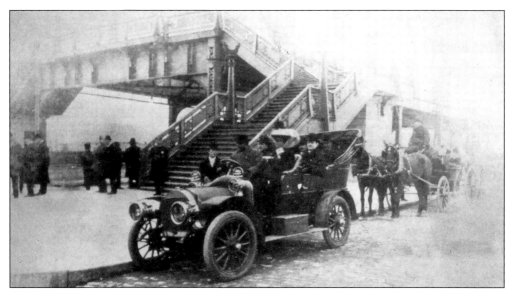

John L. Klages of Long Island City owned the first automobile driven over the bridge on opening day. Behind him are carriages. Horse-drawn conveyances, which accounted for one third of bridge traffic in 1909, were down to only seven percent within five years. This is a photograph from the *Long Island Star* newspaper. (Courtesy of GAHS collection.)

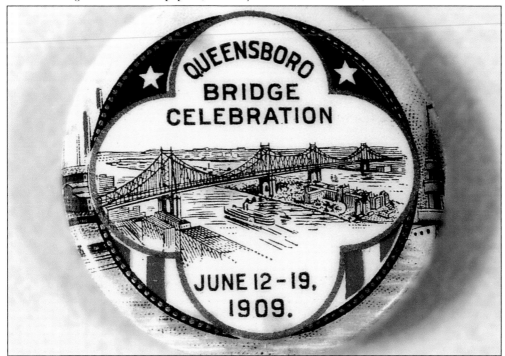

Although the bridge opened for traffic in March 1909, the official celebration took place the following June from the 12th to the 19th. Although ho-hummed by Manhattanites, Queens residents embraced the festivities. Athletic events, concerts, reunions, carnivals, fireworks, baby contests, banquets, and even an automobile race marked the weeklong calendar of events. (Courtesy of Stephen Leone collection.)

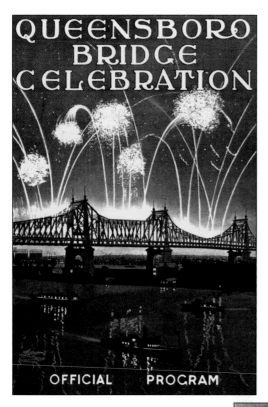

QUEENSBORO BRIDGE CELEBRATION

OFFICIAL PROGRAM

The official program of the Queensboro Bridge celebration is a fascinating 96-page supplement published by the Queensboro Bridge Celebration Committee. Priced at 25¢, it contains a detailed program of events. Also included are short profiles of the borough and the bridge, as well as biographical information about the men who fought to have Queens linked to Manhattan. (Courtesy of GAHS collection.)

The *Long Island Daily Star* (later the *Long Island Star-Journal*) was a strong advocate of the bridge and published a souvenir supplement celebrating the bridge-opening festivities. It has a short background history on efforts to build the bridge as well as interesting facts on its construction. Queens and the Queensboro Bridge were often represented by a female allegorical figure. (Courtesy of GAHS collection.)

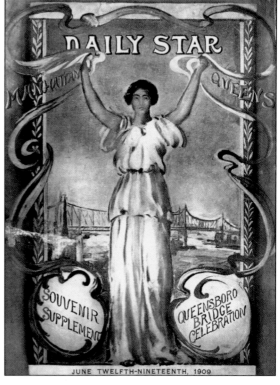

DAILY STAR

SOUVENIR SUPPLEMENT

QUEENSBORO BRIDGE CELEBRATION

JUNE TWELFTH-NINETEENTH, 1909

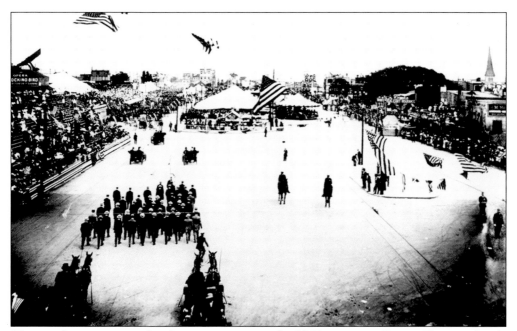

The grand reviewing stand with a seating capacity for 5,000 persons at Queens Plaza was barely finished in time for the opening ceremonies. In addition to the stand, three huge tents were erected to serve as exhibition halls for celebration events. Gov. Charles Evans Hughes gave the capstone speech following the formal hand over of the bridge to the borough presidents from the commissioner of bridges. (Courtesy of GAHS collection.)

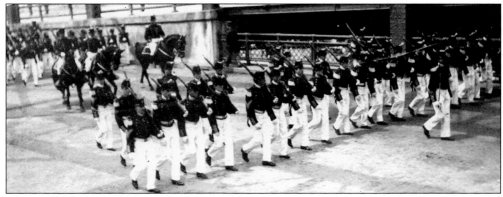

The 71st Regiment of the New York National Guard is remembered as the first National Guard regiment in the country to be mustered into volunteer service for the nation at a time of war. In full-dress uniform, these veterans of the Spanish-American War (1898) and heroes of the battle for San Juan Hill marched with other military divisions at the head of the grand parade. (Courtesy of GAHS collection.)

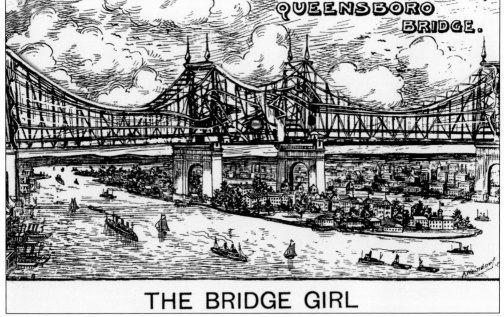

THE BRIDGE GIRL

"The Bridge Girl" may have been Elizabeth Augenti, 19, who was crowned "Queen of the Queensboro Bridge" on the final day of the opening ceremonies. She was awarded two lots valued at $1,500 in Kissena Park. Augenti worked for Long Island Guarantee Trust. In a publicity campaign advertising the bank's real estate lending, her job was to pose as a home buyer of modest means. (Courtesy of Stephen Leone collection.)

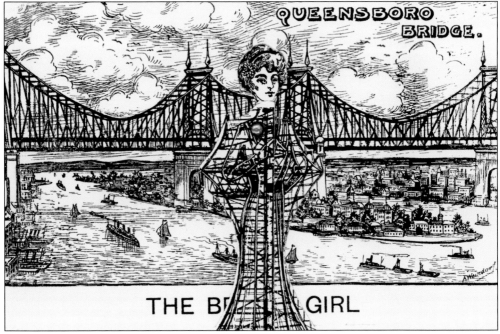

THE BRIDGE GIRL

Two halves of "the Bridge Girl" pivoted on a tiny rivet embedded in the postcard. When swung down from covering the bridge, they revealed the young lady in a long dress. (Courtesy of Stephen Leone collection.)

It was possible to obtain a souvenir of the grand celebration for a small fee by having a vendor insert one's coin into his penny press; pressure was applied, the face of the penny was altered, and a keepsake was obtained to enjoy. (Courtesy of Stephen Leone collection.)

In 1886, Bloomingdales moved uptown to 59th Street and Lexington Avenue, only two blocks from the future entrance to the Queensboro Bridge. It occupies an entire block today at that location. This embossed souvenir tray pictures the store and the Manhattan approach to the bridge. The inscription reads, "Blackwell's Bridge 1901–1908." The bridge was renamed Queensboro shortly before it opened. (Courtesy of Judith Berdy collection.)

Bloomingdales Department Store sold this commemorative silver spoon for the grand celebration. In the 1860s, Joseph and Lyman Bloomingdale opened a store specializing in ladies hoop skirts on the Lower East Side. The brothers then diversified and carried a variety of European fashions. They prospered due to their merchandising acumen. (Courtesy of Judith Berdy collection.)

Singing societies were the rage throughout the 1900s. They provided entertainment and socialization for the participants as well as the wider community. In 1909, New York City abounded with choral groups, many of them participants in the grand celebration. One amateur club from Long Island performed *The Mocking Bird*, a comic opera, night after night under the big tent designated as a theater. (Courtesy of GAHS collection.)

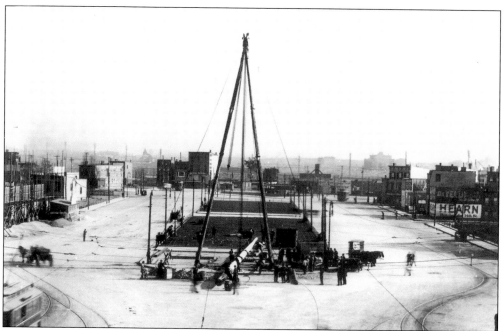

The massive sailboat *Shamrock III*, financed by British grocer and tea merchant Sir Thomas Lipton, was defeated in the 1903 Americas Cup trials. She lost her last race after her crew got thrown off course in a fog. When the boat was dismantled, Lipton donated her mast to Queens Plaza for a flagpole. The mast was raised on November 12, 1909. The Brewster Building goes up on the left. (Courtesy of GAHS collection.)

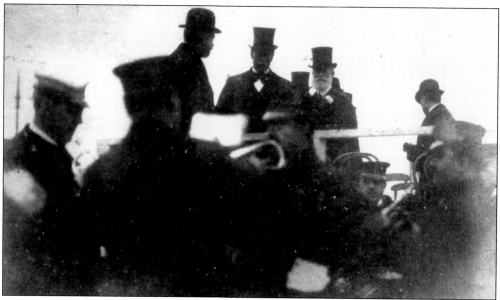

In this photograph by the *Long Island Star*, Sir Thomas Lipton, in high-hat and bowtie, stands with a group of local dignitaries during the dedication ceremony. The other gentleman was John Crimmins, a contractor who suggested the idea to Lipton. When the elevated train came to Queens Plaza a few years later, the mast was supposedly transferred to Astoria Park. Its fate is unknown. (Courtesy of GAHS collection.)

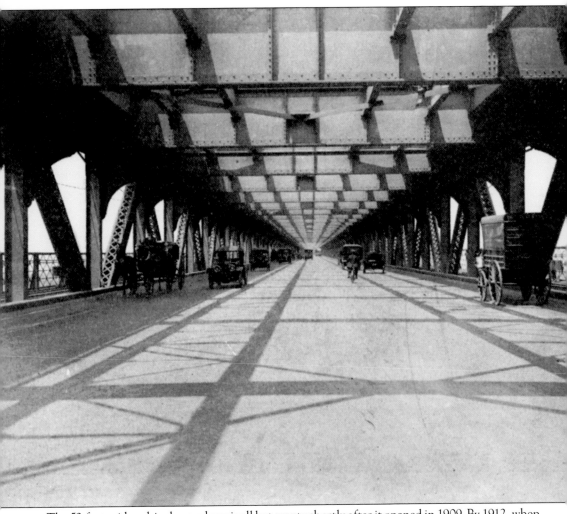

The 52-foot-wide vehicular roadway is all but empty shortly after it opened in 1909. By 1912, when 5,000 vehicles crossed in a single 24-hour period, horse-drawn vehicles were only one quarter of the traffic. By 1919, volume was more than 18,000 vehicles per day, or 14 a minute. Within six years, the daily pace ballooned to 52,000 on some days. (Courtesy of Queens Chamber of Commerce collection.)

Four

TRANSPORTATION

When it opened in 1909, the bridge made the development of the borough of Queens a certainty. Nearly a third of Greater New York, semirural and formerly isolated, suddenly had a direct line to midtown Manhattan.

The Manhattan trolley terminal was located underground on the east side of Second Avenue between 59th and 60th Streets. Five trolley lines ran out of the terminal to destinations in Astoria, Steinway, Corona, Flushing, College Point, and Queens Boulevard. In 1919, the two railroad companies, which held contracts signed in 1909 to run over the bridge, refused to renew because of the extraordinary fees charged by the city. However, the trains and their successor, the Steinway transit system, continued to provide service over the bridge through a series of temporary agreements. The trolleys were rerouted from the center lower deck to the outer lower tracks, clearing the way for vehicular traffic. Later the Steinway Lines, prior to a takeover by the city, ran a fleet of buses that served most of Queens.

The trolley bridge shuttle turned back to Manhattan at Queens Plaza on the west side of Northern Boulevard. This line ran just a mile and a half from Second Avenue in Manhattan to Queens Plaza with a stop at both Welfare Island (now Roosevelt Island) and Vernon Boulevard. At one time the mid-span stop was the only access to Roosevelt Island other than by boat.

In 1915, the island was under control of the departments of charities. Even though they maintained a fleet of 15 steamboats to transport supplies and people, it was difficult to support the considerable daily tonnage and personnel needed to care for the 8,000–10,000 persons who lived in the city-run institutions on the island. After a study, the so-called upside-down elevator storehouse was built on what is now the site of the Roosevelt Island Tram.

This unique nine-story building had a steel skeleton covered with brick on all sides, including the exposed roof. Each floor was designated to provide for a specific need of the institutions, including distributing offices, refrigerated food lockers, a restaurant, a bakery, a pharmacy and drug manufacturing, coffee roasting, and storage. The roof itself was the traffic concourse with a garage. The building was set back 60 feet to prevent any damage to the span in case of fire but linked to the Queensboro Bridge by a smaller steel connecting bridge. Daily freight and passenger traffic entered the building from the roof and descended to the street level in one of two large elevators.

The Second Avenue elevated train, after a seven-year wait, was finally connected to the Queensboro Plaza elevated station. The Queensboro system also fed trains to Queensboro Plaza from Grand Central Station (via Hunters Point). The lines went farther to Astoria and Corona. When it became apparent that the system could not handle the volume of passenger traffic, the

city expanded the subway network by tunneling under the East River between Manhattan and Queens. Work on this tunnel was completed by 1920.

By the 1940s and 1950s, all elevated railway service had stopped and tracks were removed from the bridge deck. The obsolete Queens trolley network had been abandoned by 1939 except the portion owned by the Queensboro Bridge Railway on the bridge. In 1955, a span connected Roosevelt Island to Queens, and two years later trolley service across the bridge was eliminated.

In the late 1950s, new ramps enabled the bridge to carry more traffic. The flag poles were removed in 1960. The island's unique elevator storehouse was demolished in the 1970s. The Vernon Avenue elevators were also removed.

The Welfare Island Bridge provided the only access to the island until the Roosevelt Island Aerial Tramway went into service in 1976. The trams, originally opened as a temporary means of transport from Manhattan to the island, have become a permanent feature of New York City.

In the 1980s, the New York City Department of Transportation began a half billion dollar, 25-year-long reconstruction of the bridge. From examining the stone piers, ironwork, and roadway to blasting off old paint and repainting the bridge, the structure was inspected and repaired over six phases.

The Manhattan market, which had became storage and garage space for the city, had its beautiful Guastavino tiled walls renovated and now houses high-end retail shops. The lower level of the bridge was reconfigured to carry four wide lanes with a median barrier in the center and a pathway for pedestrians and bicyclists.

The Queensboro Bridge is the only New York bridge to be assigned a New York State route number, NY 25. The road begins at the bridge and extends 110 miles east to Orient Point, Long Island.

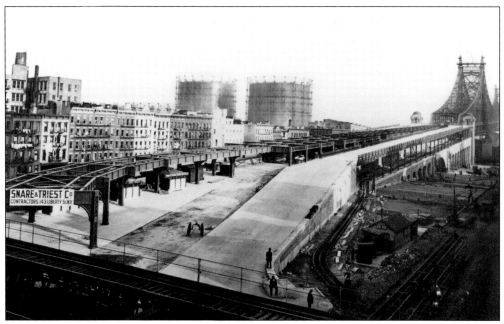

The Manhattan approach was contracted to Snare and Triest, whose sign is on the Second Avenue elevated train spur. For seven years, between 1909 and 1916, the line awaited completion of the Queensboro Plaza elevated train station. (Courtesy of GAHS collection.)

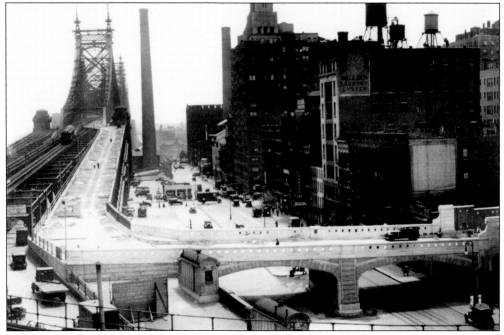

On opening day the bridge had an estimated capacity of 200,000 people per hour, with 100,000 riding in roadway traffic (trucks, automobiles, and horse-drawn wagons), elevated trains and trolley cars carrying another 60,000 passengers, and the pedestrian promenade with the capacity for an additional 40,000 people. By the 1920s, traffic lanes were changed and new ramps gave the upper-level pedestrian promenade over to automotive traffic. (Courtesy of GAHS collection.)

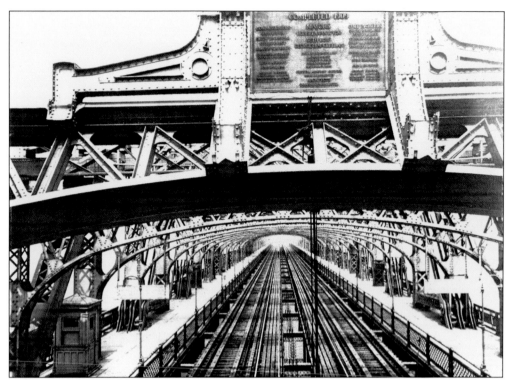

Pedestrian sidewalks and mass transit rights-of-way gradually gave way to truck and automobile lanes. Bowing to ever-changing needs, traffic patterns were modified or new ramps were added to accommodate an ever-greater demand for more capacity. Between the 1920s and 1940s, both the upper-level walkways and the elevated lines were turned over to vehicular traffic. The dedication plaque is overhead. (Courtesy of GAHS collection.)

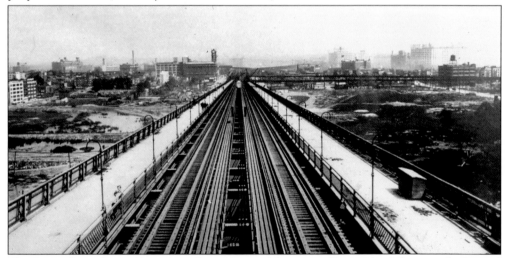

The Queensboro elevated lines from Grand Central Station and Long Island City met the Second Avenue elevated trains at Queensboro Plaza in this c. 1918 photograph. On either side, empty land was soon to be developed. The arrival of the bridge stirred life into this long-dormant area. The close proximity to booming Queens Plaza made it unthinkable to neglect this real estate. It became valuable overnight. (Courtesy of GAHS collection.)

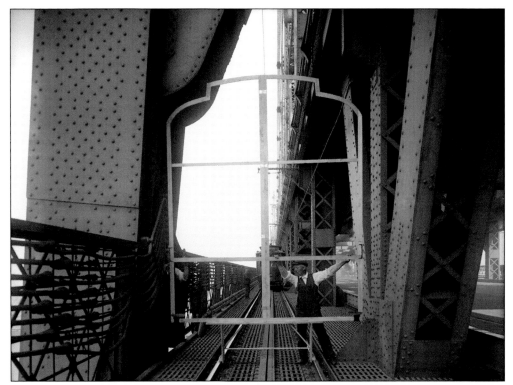

On September 17, 1909, the first trolley made a trial trip across the bridge to test clearances. A worker with a cutout for a 10-foot car walked along the outside track somewhere above Roosevelt Island. The photograph is by Eugene de Salignac, the official bridge photographer for New York City. (Courtesy of New York City Municipal Archives; photograph by Eugene de Salignac.)

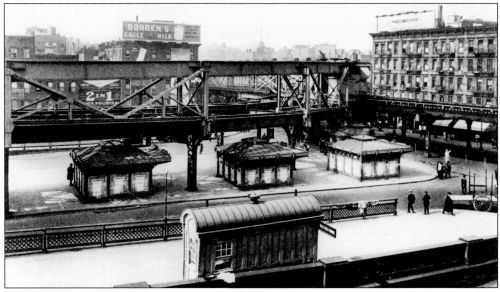

This view is from 60th Street looking south showing three of the five trolley kiosks. The building in the foreground is the women's comfort station. The Second Avenue elevated, whose trains ran over the bridge until 1942, is in the background. (Courtesy of GAHS collection.)

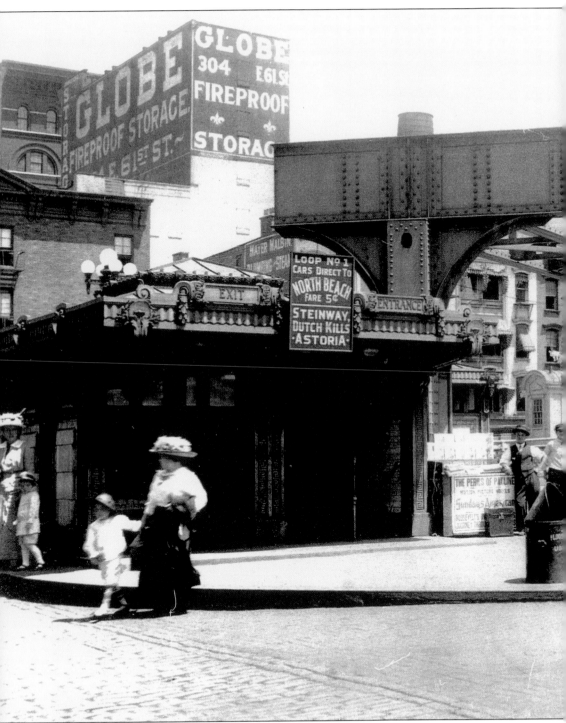

This is perhaps one of the finest views of the five trolley kiosks at the Manhattan side of the bridge on Second Avenue. It was taken shortly after the bridge opened and before the trestle for the completed Second Avenue elevated train threw the kiosks into shadows. A dozen destinations in western Queens are listed. From here a network of lines led to North Beach,

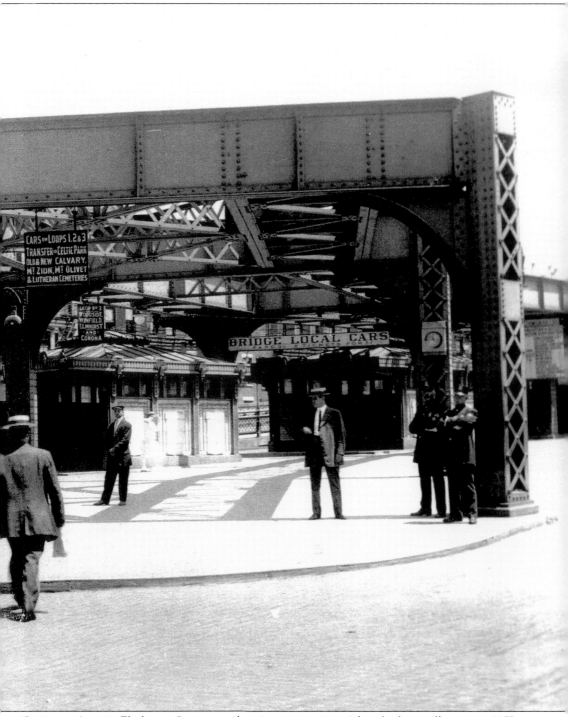

Steinway, Astoria, Elmhurst, Corona, and various cemeteries. After the last trolley ran in 1957, three kiosks were demolished. One is still here, at its original location. The second was moved to Roosevelt Island. (Courtesy of New York City Municipal Archives.)

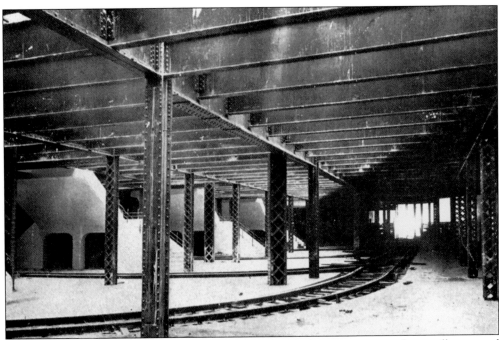

The kiosks had stairs that led to this platform below the Manhattan entrance where trolleys turned around via a horseshoe curve for their return trip to Queens. From 1910 to 1939 trolleys ran to Astoria, from 1910 to 1925 to Flushing and College Point, from 1910 to 1922 to Corona, from 1910 to 1939 to Steinway, and from 1913 to 1922 to Queens Boulevard. (Courtesy of GAHS collection.)

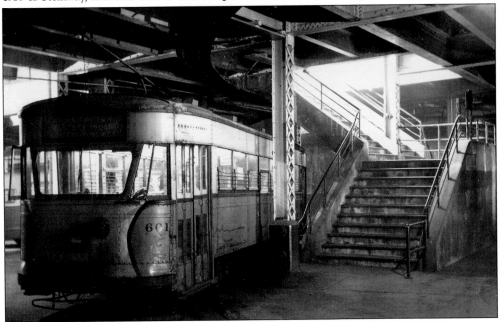

Car 601 waits in the trolley station under the Manhattan entrance. The 600 trolley car series was bought used from the New Bedford trolley system and served the Queensboro Bridge for the last years of trolley service. The numbers were never changed from the original numbering system. See also page 122 for this trolley in 2007. (Courtesy of GAHS collection.)

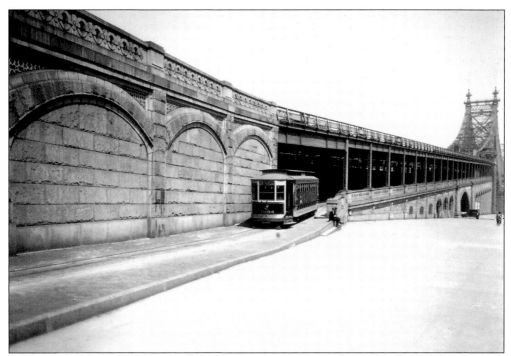

The Bridge Local line had stops at Second Avenue in Manhattan, Welfare Island, Vernon Boulevard, and Queens Plaza. The trolley just exited from the Manhattan station and is proceeding onto the south outer roadway for its trip to Queens. (Courtesy of GAHS collection.)

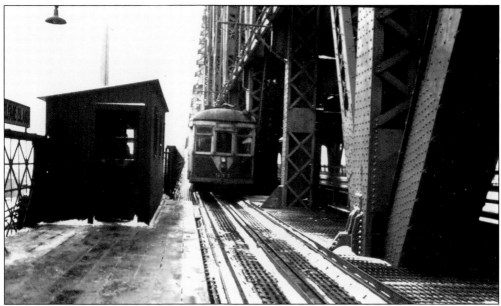

A trolley approaches the Welfare Island stop in mid-river during a snowy winter day. Cars and trucks had a special light to stop traffic on the bridge, enabling them to make the turn onto the warehouse roof. The Queensboro Trolley had to stop and let this traffic across its tracks too. (Courtesy of GAHS collection.)

After stepping off the trolley, eastbound riders walked through this underpass, from the south to the north side of the bridge, to reach the storehouse elevator building on Blackwell's Island. The walkway was not well protected from winter weather and vibrated from the traffic overhead. (Courtesy of RIHS, Eleanor Schetlin collection.)

At the entrance foyer to the storehouse building on the north side of the bridge, there were five elevators capable of handling passengers and trucks. The building was demolished in the 1970s for the Roosevelt Island Tramway station. (Courtesy of RIHS, Eleanor Schetlin collection.)

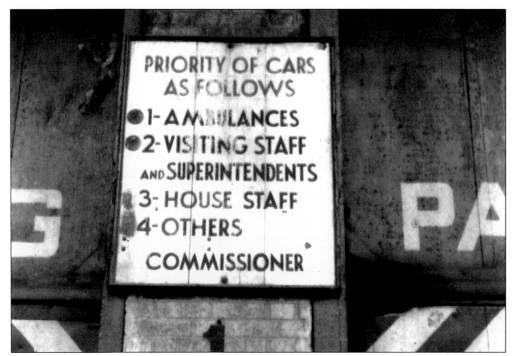

Blackwell's Island (Welfare Island after the 1920s) contained a number of institutions during its city stewardship. An almshouse, penitentiary, hospitals, asylums, and the like dictated that all employees and visitors be under a host of rules and regulations while on the island. One such regulation listed the order of priority for elevator use. (Courtesy of RIHS, Eleanor Schetlin collection.)

Above the elevator entrance, the seal of the City of New York looked down on passengers ready to enter the storehouse building. Beyond these doors, one was on official ground. (Courtesy of RIHS, Eleanor Schetlin collection.)

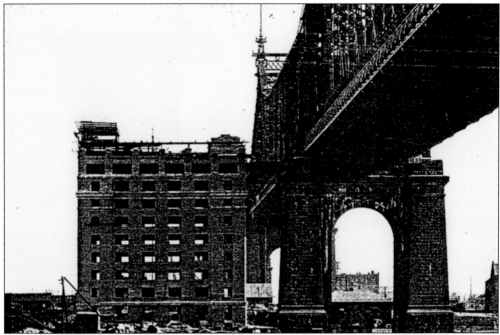

Designed by Benjamin Levitan and opened in 1916, the elevator storehouse was both an access route to the island and a building that received deliveries directly on each floor via truck. Vehicles entering on the roof from the lower roadway drove directly into the building's elevator. (Courtesy of RIHS collection.)

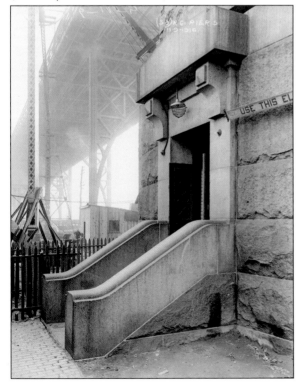

The two elevators and iron staircases in the Vernon Avenue anchor tower opened in August 1911. Each 1,000-pound lift traveled at a rate of 300 feet per minute, traversing the distance from this door, at street level on Vernon Boulevard, to the roadway in about 20 seconds. Each elevator could carry about 23 passengers. (Courtesy of New York Transit Museum.)

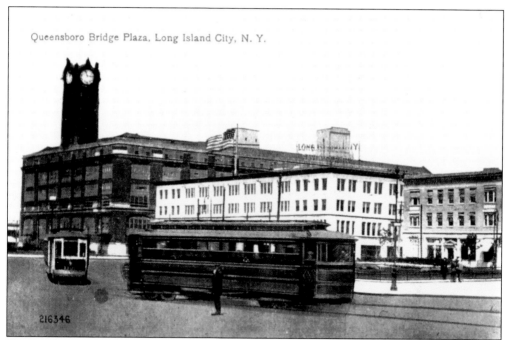

Queensboro Bridge Plaza, Long Island City, N. Y.

216346

On October 4, 1909, regular trolley shuttle service began over the bridge from Second Avenue in New York to Bridge Plaza in Queens. On February 5, 1910, service was extended through to Dutch Kills, Astoria, Steinway, Corona, Flushing, and College Point lines. (Courtesy of Bob Stonehill collection.)

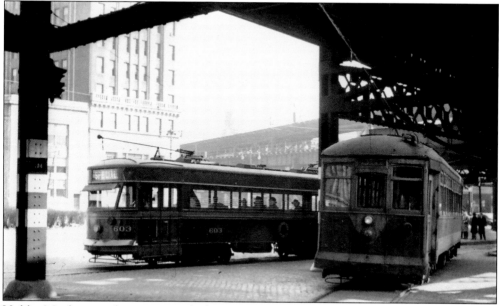

Unlike Manhattan, there was no platform in Queens that marked the end of the line but a loop of three tracks at Jackson Avenue and Northern Boulevard near a waiting room. The Queensboro Bridge shuttle finally succumbed to buses on April 7, 1957. Exactly a week later the elevators and staircases in the Long Island City tower of the Queensboro Bridge shut down. (Courtesy of Stephen Leone collection.)

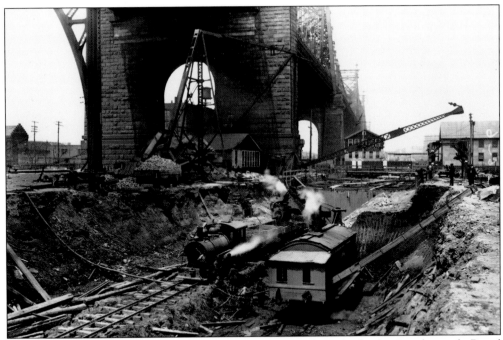

The dual subway agreement in the early 1920s provided for both the Interborough Rapid Transit Company (IRT) system's Second Avenue elevated train and the Brooklyn-Manhattan Transit (BMT) system's Broadway–59th Street subway to cross the Queensboro Bridge and then go to Queensboro Plaza. Concerns about train weight, and the impracticality of taking away traffic lanes from skyrocketing demands from automobiles and trucks, made a tunnel a better option. (Courtesy of GAHS collection.)

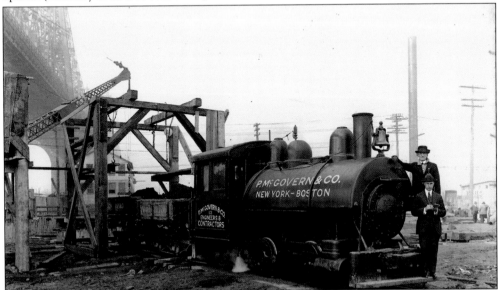

Patrick McGovern and Company was awarded a $4.1 million contract in August 1916 to build a tunnel under the river. This option was about twice as expensive as the aboveground bridge route. A shaft was built on Vernon Boulevard, and the tunnel was "holed through" on October 15, 1918. (Courtesy of New York Transit Museum.)

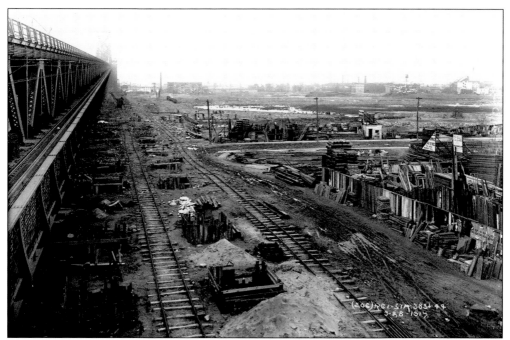

The completed bridge was a major incentive to fill in the undeveloped Sunswick meadows just to its north. A temporary narrow-gauge railroad carried the cinders and subway excavations over the swamp where dirt cars dumped and distributed the fill. In the foreground, holes are being dug for the pillars that supported the elevated line between the tunnel portal and Queensboro Plaza. (Courtesy of New York Transit Museum.)

Service opened in August 1920 between Lexington Avenue in Manhattan and Bridge Plaza in Queens. The tube is 18 feet in diameter, dips as low as 125 feet beneath water level, and is nearly three miles in length. The photograph shows the half-mile portion between the mouth of the tunnel and Queensboro Plaza. To the left is the Brewster Building. (Courtesy of GAHS collection.)

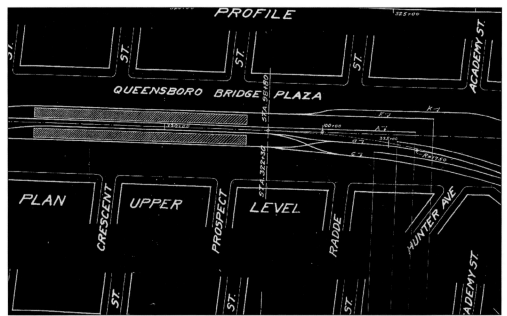

On October 7, 1913, the firm of Snare and Triest, which built the elevated train structure in Manhattan, won the contract for the Queensboro Plaza elevated train station; that project would ultimately cost over $1 million. Service started on November 6, 1916. The station was one of the largest in the system. It was 480 feet long and had two levels with a total of eight tracks. (Courtesy of Queens Chamber of Commerce collection.)

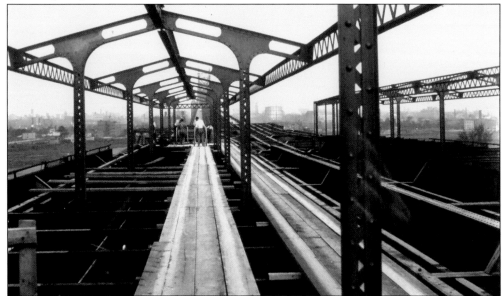

The four tracks on the station's lower level carried trains into Manhattan. The northern platforms had service into Manhattan via the 60th Street tunnel. The southern platforms serviced trains that crossed the river on the Queensboro Bridge or through the Steinway tunnels in Hunters Point. The upper level, pictured, was for outbound trains. Service was planned for Astoria, Corona, and Brooklyn. Running time to Grand Central was 10 minutes. (Courtesy of GAHS collection.)

A number of transit companies ran trolleys over the bridge: Queensboro Bridge Railway Company, the New York and Queens Railway, the Third Avenue lines, the Manhattan and Queens Traction Company, and the Steinway lines. As late as the 1990s, serious discussions were held on the feasibility of running a monorail across the bridge to the airports. (Courtesy of RIHS collection.)

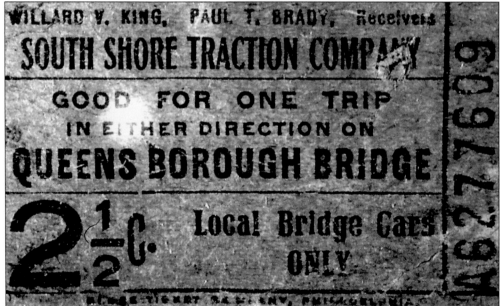

Trolley tickets to ride over the bridge were issued by the South Shore Traction Company for 2.5¢ each way. Later the Queensboro Bridge Railway Company issued tokens. Again the fare was two rides for 5¢. (Courtesy of Judith Berdy collection)

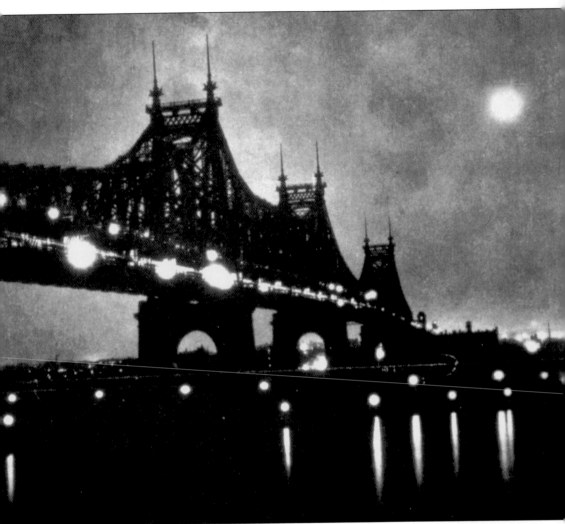

The annual Christmas edition of the *Long Island Star*, dated December 15, 1914, had this special art supplement. Printed on heavy stock paper, it was suitable for framing. The photographer was Dr. W. T. Kilmer, who exposed the film for 15 minutes on the roof of a house on East 53rd Street in Manhattan. The full moon, the lights reflected on the water, and local landmarks such as the Terra Cotta Works and Brewster Building over a mile distant are clearly visible. (Courtesy of GAHS collection.)

Five

THE QUEENSBORO BRIDGE AND QUEENS BOROUGH

Following the Civil War, the development of Queens was spurred on by the cheap land and labor available for industrialization, the close proximity to Manhattan, and by a wave of European immigrants seeking work and a place to live. Most heavy industry was near waterborne transportation. Later steam-powered ferries and local rail lines could transport both passengers and freight from one location to another. Flushing, Jamaica, College Point, and Woodhaven were settled. Prior to 1910, the trolley network had built a series of suburbs that dotted the landscape. Newtown Creek was fully industrialized. And, in Astoria near the East River, a 400-acre settlement was developed by William Steinway to provide for workers at his piano company.

Everyone recognized that the borough was at a tiny fraction of its potential. The "Garden of New York" remained a rural area with lush farms, estates, villages, and small towns. However, dramatic changes would follow the consolidation of Queens with New York City in 1898. Unification made construction of the Queensboro Bridge possible.

For years industrialists, entrepreneurs, and civic leaders had fought for a bridge to connect Manhattan and Queens. When the gate finally opened, they were prepared for the boom that followed. Financial institutions sharpened their pencils, large tracks of open land were purchased, houses were built, and hosts of enterprises were ready to supply services and goods to Queens's new residents.

When the Queensboro Bridge opened in 1909, traffic of all sorts flowed across the great bridge, forming an ever-expanding delta of urbanization from the Queens Plaza terminal. At this time, Queens had a population of 275,000, but in 10 years it increased to half a million.

Queens was heralded as a safe, healthy suburban place to live and now only a short ride from downtown Manhattan. It enjoyed the fruit of the reform movement, where, in contrast to the tenements of Manhattan, model flats and planned residential communities are built, and workers enjoyed airy fireproof factories open to bright sunshine. A typical real estate advertisement from the time read, "Over Queensboro Bridge to Queensboro Hill in Beautiful Flushing, L.I . . . Lots–$200 UP, liberal cash discount or easy monthly payments. Houses–$4,500 Up, built for homes not for speculation. Queensboro Hill from its natural advantages will appeal to the Thinking Homeseeker and Investors. One Half Hour from Herald Square Now. Close to churches, modern schools, banks, markets, etc."

The most rapid period of urbanization occurred between 1920 and 1930, when the population soared to over a million. The Great Depression of the 1930s stalled the previous decade's run-away building boom. The city embarked on large public works projects such as the Triborough Bridge and the Grand Central Parkway (opened in 1936). The 1939 completion of LaGuardia Airport arrived in time for the New York world's fair. The 1939–1940 event put Queens in the international spotlight. Preparations for the fair not only provided employment but also vastly improved the infrastructure of the borough.

Another building boom followed World War II when any open farmland and woods were soon covered with residential and commercial buildings. Queens was home again for a world's fair, this time in 1964–1965. Over 55 million people from around the world attended. Again the fair brought the borough infrastructure improvements in the Throgs Neck Bridge, Long Island Expressway, and Shea Stadium.

In 1965, the United States Congress reformed immigration law and New York City, always an entry for those seeking new opportunities, experienced a new wave of immigration. Queens is the 10th most populous county and one of the most ethnically diverse areas in the United States, with immigrants from many countries comprising almost half of its official population of 2.2 million.

Another building surge is underway to supply residential and commercial space for those who find living in Manhattan unattainable or undesirable. Although completely urbanized, the thriving borough of Queens continues to remake and identify itself in accord with the social and economic forces that drive the New York region.

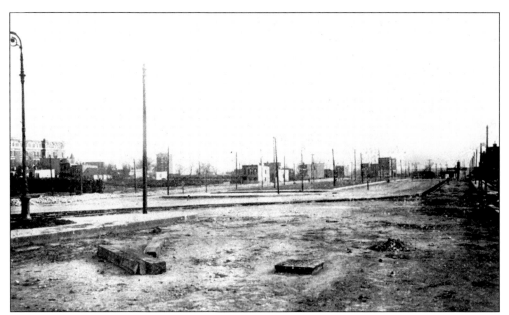

The land for Queens Plaza and the Queens approach, from the East River to Northern Boulevard, is a strip between 160 and 250 feet wide and cost $1 million. Only a few buildings had to be moved. Queens Plaza alone was 1,152 feet long. Charles Meads and Company did grading and paving. This view faces east with the old Long Island City High School on the left. (Courtesy of GAHS collection.)

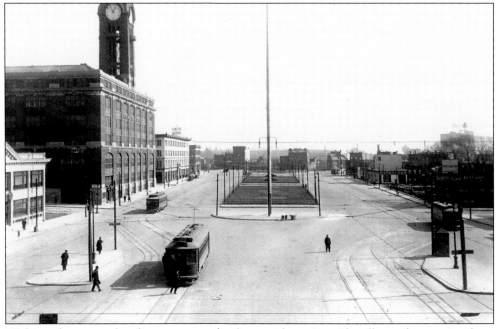

Within a few years, the plaza starts to take shape with paving, sidewalks, and sewers in place. The ubiquitous trolley, the imposing Brewster Building, and Sir Thomas Lipton's flagpole complete this eastern perspective. The plaza is all but empty; the photographer perhaps waited for a Sunday morning to snap this image. (Courtesy of GAHS collection.)

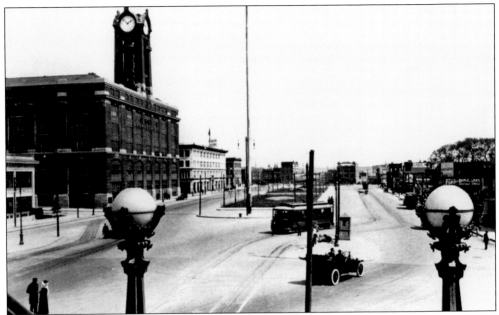

This view of Queens Plaza, taken about the same time as the previous page, shows the ornamental lights at the foot of the pedestrian walkway. The two 18-foot-high lights in Manhattan had the names of four boroughs inscribed on their bases. All traces of Ravenswood Park are now gone, but the residential area is still to the south of the bridge. This view looks east. (Courtesy of GAHS collection.)

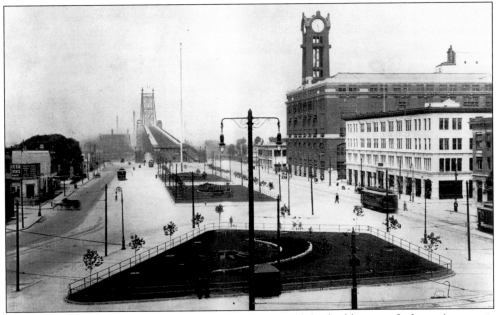

Again, a western view of the plaza, perhaps from one of the buildings on Jackson Avenue, is seen. In contrast to the images on the previous page, the islands in the plaza are beautifully landscaped with a crescent moon in flowers in the plot nearest the photographer. The plaza enjoyed sunlight for less than five years before the elevated train permanently threw it into shadow and noise. (Courtesy of GAHS collection.)

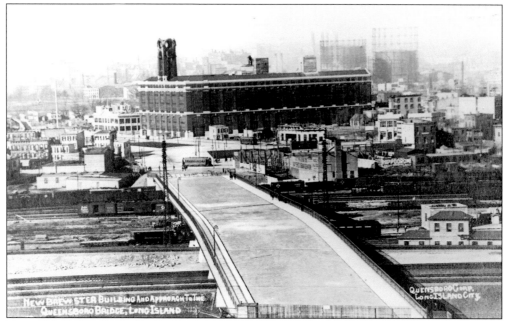

To provide an outlet for the traffic to Queens Boulevard, a great steel viaduct across the railroad yards was built by the Pennsylvania Railroad. It also connects Queens Plaza to Thomson Avenue and Van Dam Street. This bridge is 100 feet wide and 1,830 feet long and is supported by 18 concrete piers and two massive abutments. It opened on December 29, 1910. (Courtesy of GAHS collection.)

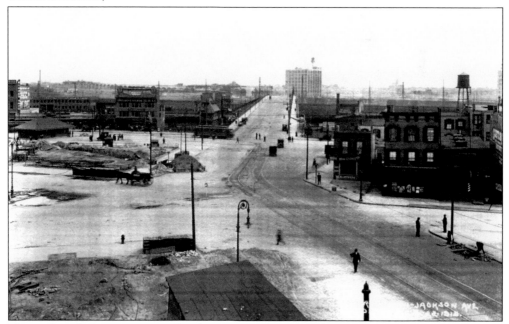

The viaduct, looking east in 1915, is directing traffic toward the new industrial Degnon terminal seen rising in the distance. The landscaped plaza is gone and is now being torn up for the pillars of the Queensboro Plaza elevated train station, which will be in service the following year. The building to the left is a trolley waiting room. (Courtesy of GAHS collection.)

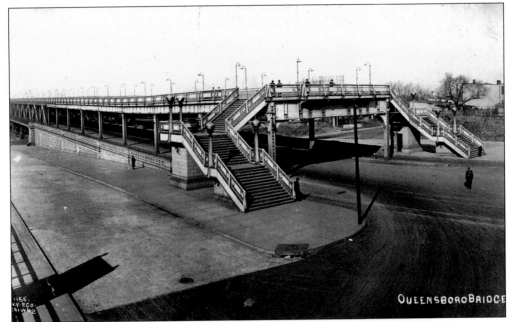

It is difficult to believe that Bridge Plaza, as Queens Plaza was then called, could be all but empty of traffic. A handful of people, and no traffic, motorized, steam, or animal, can be seen. The images at the top of this and the facing page fit together. (Courtesy of Stephen Leone collection.)

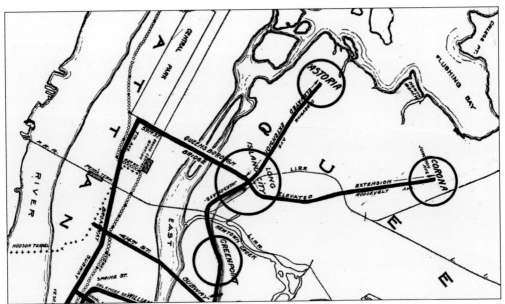

The central role the Queensboro Bridge played in the rapid transit system of Queens is illustrated by the map. Even before additional subway service was opened through the Steinway tubes to Grand Central, and the Independent system's lines of the 1930s to Brooklyn and Jamaica, Queens Plaza was the undisputed transit hub for the borough. (Courtesy of Queens Chamber of Commerce collection.)

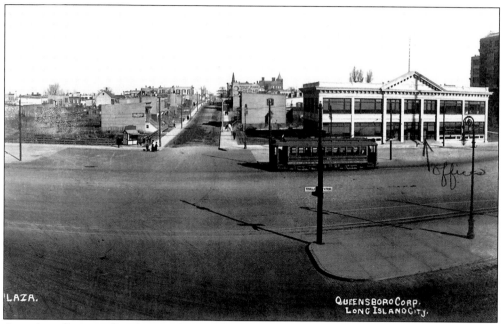

A single trolley trundles along in front of the offices for the Queensboro Corporation, the entity responsible for developing Jackson Heights. The dreamy state of this end of the bridge stands in stark contrast to the Manhattan face on Second Avenue. In the center is Crescent Street. The white Queensboro building still stands.(Courtesy of Stephen Leone collection.)

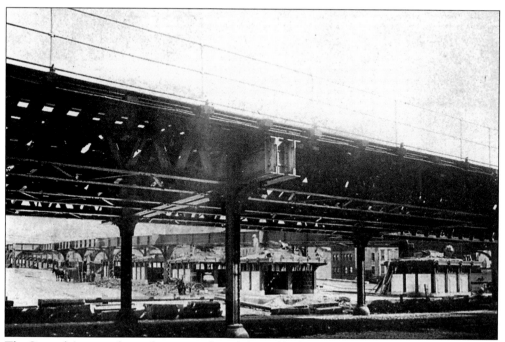

The Second Avenue elevated train trestle and the trolley kiosks stand ready to fuel the explosive growth of Queens and Long Island. This picture must have been taken just before the bridge opened, as construction debris fills the sidewalks. (Courtesy of GAHS collection.)

The New York parks and bridge commissioners, in a joint announcement from April 1912, boasted that Queens Plaza in Long Island City was to be made "a thing of beauty." They stated further that it was to be "equal to the entrance to any park." The globe lamps, ornate railings, and smoothly dressed stone made a stunning gateway to Queens. (Courtesy of New York City Municipal Archives.)

Queens Plaza had a large 75-foot rectangle that displayed a sunburst of seasonal flowers planted around a Japanese cherry tree. Other plots held a 30-foot five-pointed star, a 50-foot oval, a 20-foot circle, and in the fourth (pictured), a 60-foot diamond flanked by two 20-foot circles of flowers. This view faces south with the Pennsylvania Railroad Power Plant in the background. (Courtesy of Dan Lenore collection, George P. Hall and Sons Archives.)

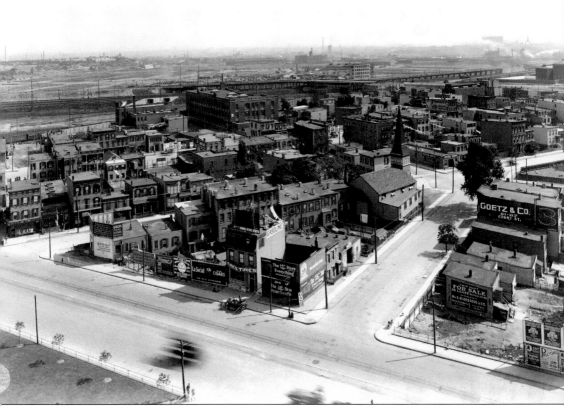

Not everyone benefited from the new bridge. This extraordinary aerial view to the south and east of the bridge was perhaps taken from the Brewster Building roof. It is the community of Dutch Kills, a once thriving neighborhood that was doomed by the growing noise and traffic from the bridge. As in neighboring Hunters Point, also in Long Island City, new travel patterns bypassed a once vibrant community, throwing it into decline. (Courtesy of New-York Historical Society collection.)

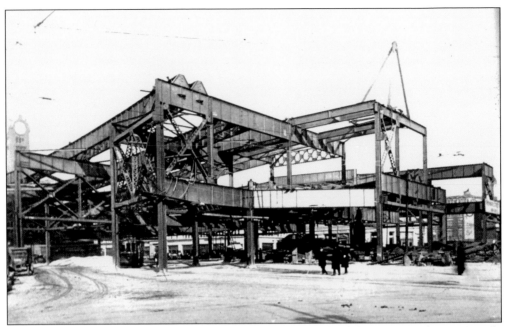

The dual contracts agreement of 1913 was responsible for much of the Queens subway network. The two subway networks (IRT and BMT) and the city agreed to share in the financing and the construction of the subway. Only the Panama Canal, financed by the federal government, was more expensive. The two lines in Queens (pictured here at Queens Plaza) would be jointly controlled by the IRT and BMT. (Courtesy of GAHS collection.)

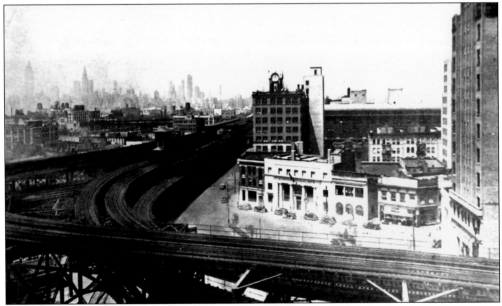

Mid-20th-century Queens Plaza, with its cluster of businesses and banks, along with the tangled network of transit lines, remained the commercial nerve center for the borough. Although diminished in importance when Queens Borough Hall moved to Kew Gardens in 1940 and the northern platforms of Queensboro Plaza were removed in the 1950s, hundreds of thousands of people make their way through the teaming plaza each day. (Courtesy of GAHS collection.)

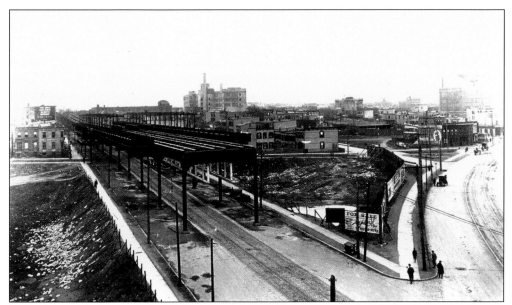

On March 11, 1913, Cooper and Evans received the contract to build the Astoria Extension to Ditmars Boulevard. Although the work was completed by January 1915, it was idle until February 1917 as it awaited completion of the Queensboro Plaza Station and the Queensboro Subway. Northern Boulevard (right) and 31st Street are pictured. The number of commuters on the line doubled within three years of operation. (Courtesy of GAHS collection.)

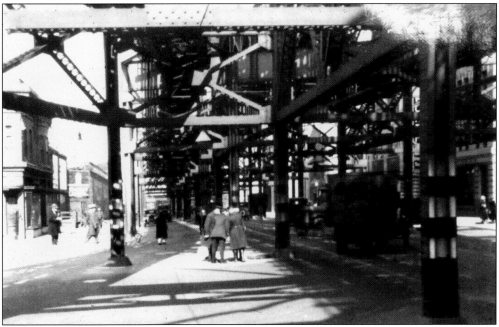

Northern Boulevard (then called Jackson Avenue) for its first few blocks had a noisy, clattering elevated train overhead before it veered onto 31st Street. The terminus of this line, at Ditmars Boulevard, was less than four miles in a straight line from Grand Central Station. It was closer to Grand Central than 125th Street, Manhattan, or the Battery. (Courtesy of GAHS collection.)

The Queensboro Arena, at 40th Avenue and Northern Boulevard, seated 4,000 in an outdoor setting. Here Harry Balogh, the ring announcer of his generation, defined the craft and learned his trade. The world heavyweight title at the massive (72,000-seat) Madison Square Garden Bowl, nearby, changed hands four times in four years. Both venues owed their existence to easy access to mass transportation from Queensboro Plaza. (Courtesy of GAHS collection.)

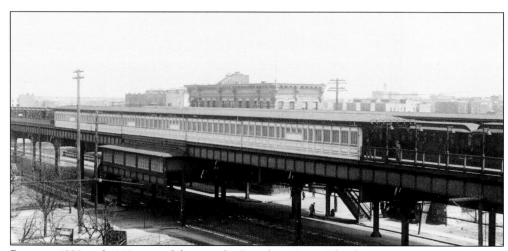

Between 1920 and 1929, annual fares at the Broadway, Long Island City station of the elevated train, just three stops from Queensboro Plaza, went from 2.5 million to more than 5 million. As the bridge advocates had predicted, the bridge opened a period of great prosperity, unbounded optimism, and an almost unlimited faith and seemed to prove the credo of "onward and upward" was an attainable, practical goal. (Courtesy of GAHS collection.)

Phipps Gardens, by architect Clarence E. Stein (who also designed nearby landmarked Sunnyside Gardens), was a planned community built in the 1930s. The apartments originally rented for around $17 per room. Transportation across the Queensboro Bridge was a selling point in this brochure. (Courtesy of Vincent Seyfried collection.)

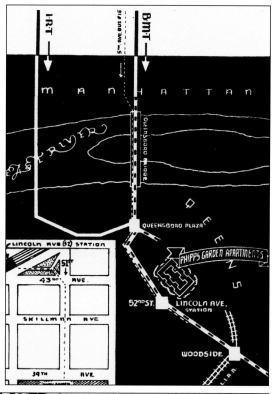

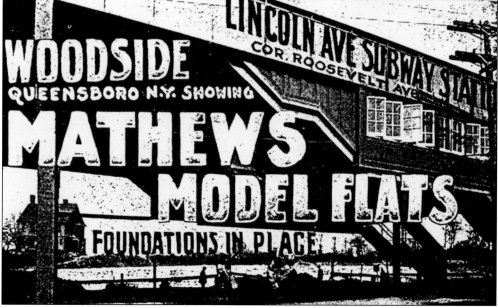

The 1909 Queensboro Bridge and the 1917 IRT elevated train line to Corona opened large stretches of real estate to developers. The prolific G. X. Mathews Company actually held one-fourth of all building permits in Queens in 1916. The line actually placed these stairs at the back of the station to accommodate his new development in Woodside. (Courtesy of Mathews family collection.)

Bridge Plaza was the undisputed financial center of Long Island City and the borough of Queens. Pictured are the New York National Irving Bank, the American Trust Company, and the Plaza Branch of the Corn Exchange Bank in this view facing northwest on Queens Plaza North. (Courtesy of Queens Chamber of Commerce collection.)

Degnon terminal was the largest industrial complex near the Queensboro Bridge, which not only provided access to customers from midtown Manhattan, but was a transit artery for the terminal's workforce. Looking east from the Sunnyside Yards, one sees concrete pouring towers, symbols of the industrial growth of Queens after the bridge opened. The images at the bottom of this and the facing page fit together. (Courtesy of Queens Chamber of Commerce collection.)

This photograph, taken in April 1920, shows the Long Island City Savings Bank, the First Mortgage Guarantee Company, and the Title Guarantee and Trust Company (the building upon which construction work had just started). A branch of the Bank of Manhattan Company and the millstones embedded in the traffic island (right) are in this northeastern perspective of Queens Plaza North. The columned, former bank building was demolished in 2007. (Courtesy of Queens Chamber of Commerce collection.)

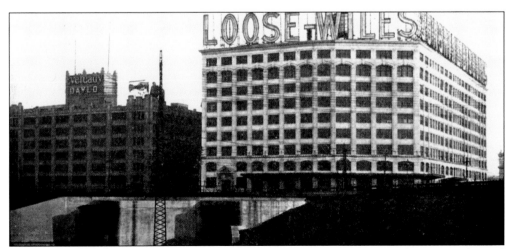

Nearly a century after this photograph (also taken in April 1920), the Degnon Realty and Terminal Company buildings and the entrances to the East River rail tunnels to Pennsylvania Station still make an impression. From left to right are (opposite page) Packard Motor, White Motor Trucks, American Chicle; (this page) American Ever Ready, and the huge sunlit Loose-Wiles Biscuit Company. (Courtesy of Queens Chamber of Commerce collection.)

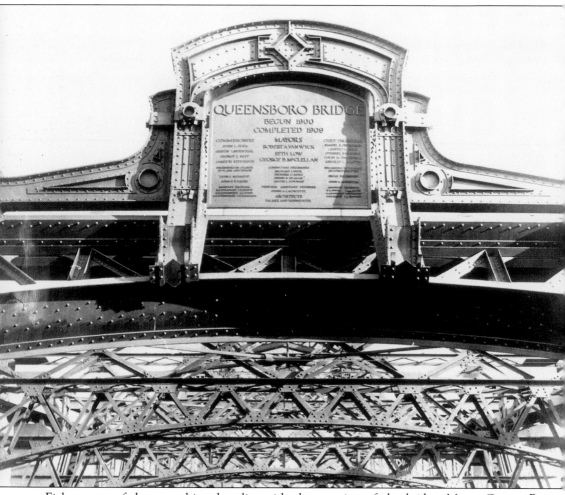

Eighty years of dreams achieved reality with the opening of the bridge. Mayor George B. McClellan, engineer Gustav Lindenthal, architect Henry Hornbostel, and sundry commissioners, officials, and engineers inscribed their names on the dedication plaque displayed for pedestrians and commuters to see. They are over both the Queens and Manhattan portals on the upper roadway. (Courtesy of GAHS collection.)

Six

THE FIRST CENTURY

For almost a century, the Queensboro Bridge, a work of art and of engineering genius, served the purpose for which it was built—to link the communities of Manhattan Island with those of Long Island. Since horse-drawn carriages first rattled over the bridge in 1909, it has gone through extraordinary changes fueled by technology, communications, and transportation.

Over the decades, the bridge's decks were altered or reconfigured to meet the evolving traffic requirements of the region. The upper deck of the bridge originally held two rail tracks and a like number of pedestrian lanes. The lower deck had four trolley and three vehicular lanes. The Second Avenue elevated train tracks were later removed. The trolley lanes were eliminated in the 1950s. For several decades the bridge carried 11 lanes of automobile traffic.

In the late 1960s and 1970s, the city of New York experienced a time of fiscal hardship and social decline. All routine maintenance of city properties was deferred for years. The grand bridge, pictured on postcards shining in the sun with flags flying from spires atop each pier, had become corroded and in need of major repair. In 1978, inspectors determined that the two outer roadways of the lower deck were so weak the city engineers ordered them closed to traffic.

Concerns regarding the bridge's safety increased. In response, the New York City Department of Transportation awarded a 25-year contract to rebuild the Queensboro Bridge. The target date for completion for this half-billion-dollar project was 2009, the year of the bridge's centennial.

Between 1981 and 2001, both decks and approaches to the bridge were reconstructed; the truss chords, bridge piers, and towers rehabilitated; and the deck at the Manhattan anchor pier was replaced. Beams, tie angles, and plates were strengthened and new railings and barriers installed. Electrical systems and drainage systems were put in place and the stonework cleaned and pointed.

The marketplace at the Manhattan approach was restored, but only two of the original five kiosks, where tickets for the trolleys were once sold, survived demolition. In Manhattan, one refurbished kiosk stands at its original location at the entrance to the bridge at Second Avenue. This decorative landmark is surrounded with bollards to protect it from being accidentally struck by passing traffic. The other kiosk is located on Roosevelt Island at the terminal for the Roosevelt Island Tram. It now houses the visitor center run by the Roosevelt Island Historical Society.

Since 2003, the work has concentrated on repainting all steel surfaces of both the bridge and its approaches. In the past, the bridge was painted with lead-based paint. To prevent paint chips from falling to the ground or fouling the air, the work area is covered with a canvas tarpaulin, which moves back and forth across the span like a giant caterpillar from Queens

toward Manhattan. Inside, workers are scraping and sandblasting the structure. Finally, they are applying a rust-retardant, epoxy-based paint whose custom colors are called mesa tan and Queensboro brown.

The Queensboro Bridge is not only one of the longest cantilever bridges in the world, but it is also one of the most heavily used. Between the east and west anchorages, it is 3,724 feet long. The total length is 7,449 feet from the Queens approach to the Manhattan approach. Every day it carries approximately 200,000 vehicles. It has been reconfigured to carry nine lanes of vehicular traffic. Pedestrians and bicycles use one lane, the north outer roadway of the lower deck.

It has four 350-foot steel towers supported on stone piers and interlacing steel truss work. Masonry approaches that allow the passage of street traffic on the Manhattan side are lined with attractive Guastavino tiles. Each year the bridge is on international television during the running of the New York City Marathon.

The bridge remains today as both "a work of art and tool of travel." In 1974, this august structure was designated a national monument.

The Queensboro Bridge, from its inception, remains a point of pride for the borough of Queens. Its residents conceived and nurtured the bridge that became the catalyst for its development. When civic, government, and cultural forces share the conviction to collaborate successfully, the city is blessed with something that is beautiful, useful, and iconic. It may be a new century, but the bridge remains an exuberant piece of the urban fabric.

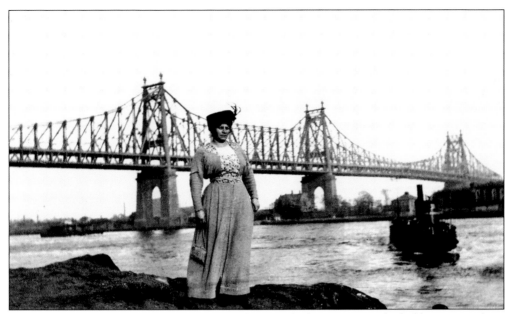

When cameras were mass marketed in 1901, photography became a popular hobby. New Yorkers, native and immigrant alike, loved to document an amazing city that seemed, with each passing season, to boast new landmarks or engineering marvels. Dressing in her Sunday best, this woman proudly poses along the Manhattan shoreline. (Courtesy of Stephen Leone collection.)

The early years of the 20th century, when living standards and life spans started to rise, were known as the "confident years." With the world's longest bridges and tallest buildings in their backyard, residents of a newly expanded Greater New York looked to the future with self-assurance. A Manhattan family, perhaps from Sutton Place, enjoys a day of sledding with the Queensboro Bridge as a backdrop. (Courtesy of Stephen Leone collection.)

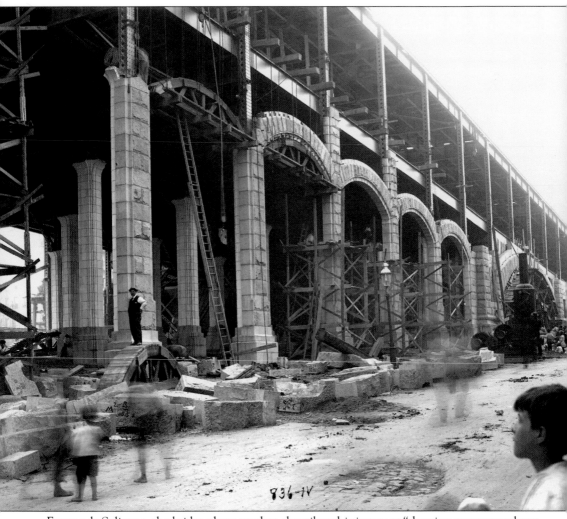

Eugene de Salignac, the bridge photographer, describes this image as "showing masonry column and arches between Sutton Place, First Avenue to end." He inadvertently captures the wonder of a young lad's face and a group of barefoot friends at the construction site. The longest bridge in New York City is going up before their eyes, conceivably across the street from their tenement house. (Courtesy of New York City Municipal Archives; photograph by Eugene de Salignac.)

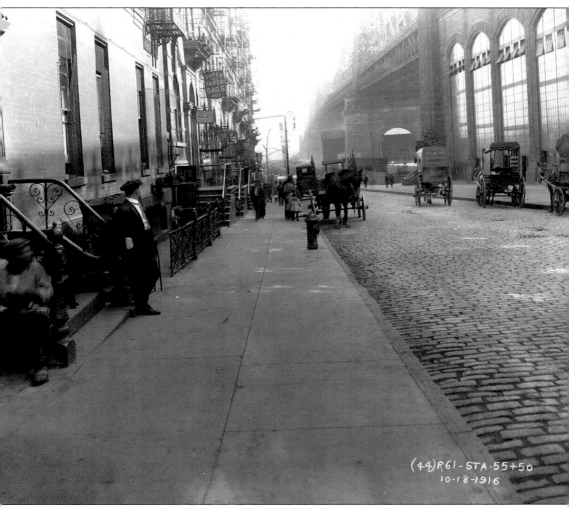

Manhattan's East 60th Street (between First and York Avenues) may give the appearance of a quiet lazy afternoon, but the people on the block would disagree. Facing the bridge during summer days in 1916, before air-conditioning and with open windows, the noise, dirt, and stench from the farmers market and 10,000 vehicles and horse carts traveling over the bridge every day must have been overpowering. (Courtesy of New York Transit Museum.)

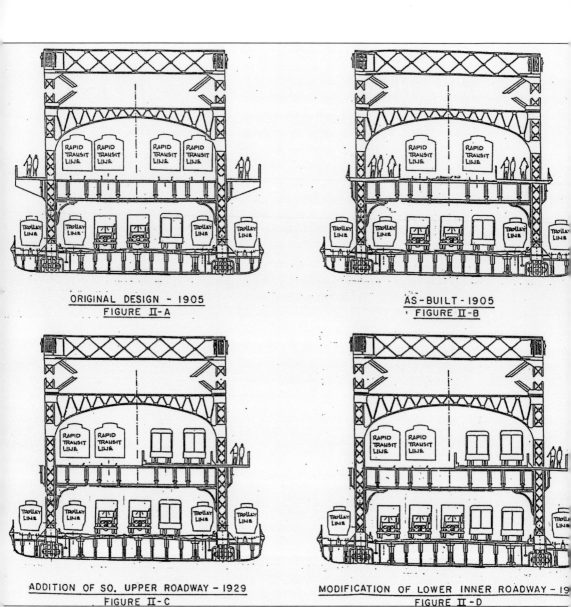

ORIGINAL DESIGN - 1905
FIGURE II-A

AS-BUILT - 1905
FIGURE II-B

ADDITION OF SO. UPPER ROADWAY - 1929
FIGURE II-C

MODIFICATION OF LOWER INNER ROADWAY - 19
FIGURE II-D

The bridge design changed over time, reflecting the shifting modes of transportation. Even before the bridge was completed, the Quebec Bridge collapse in 1907 prompted a change in the original design. The four upper-level elevated train tracks were quickly cut to two. When the bridge opened, six mass transit lanes, three vehicular roadways, and two pedestrian sidewalks reflected that breakdown of travel at the time. Automobile and truck traffic gradually took over. The last trolley ran in 1957. (Courtesy of RIHS collection.)

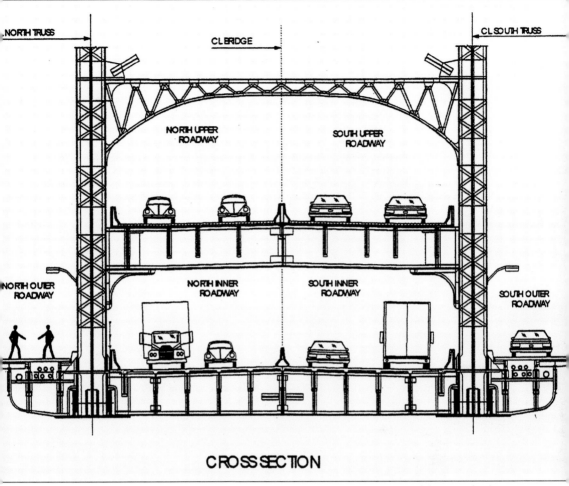

CROSS SECTION

The bridge is currently configured with four lanes on the upper roadway and four on the lower roadway. As there is a permanent median, the lower-level lanes cannot be switched each rush hour as in the past. The south outer roadway on the lower level is also for vehicles, while the north roadway is reserved for pedestrians and bicycles. (Courtesy of RIHS collection.)

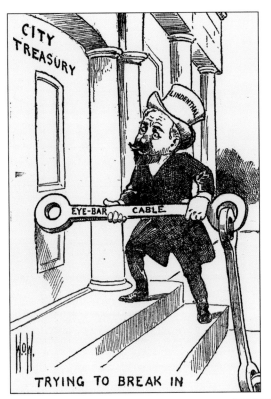

CITY TREASURY

LINDENTHAL

EYE-BAR CABLE

W.O.W.

TRYING TO BREAK IN

Although history credited Gustav Lindenthal as one of the most brilliant bridge builders of his day, he encountered controversy during and after his tenure as commissioner of bridges. He was appointed by reform mayor Seth Low (who opposed the patronage machine), and Tammany politicians in New York attacked Lindenthal's designs and lampooned him in this cartoon. The Committee of Forty in Queens felt he rode roughshod over their suggestions. (Courtesy of GAHS collection.)

Controversy over the bridge disappeared by opening day, for it was immediately apparent that this was a civic and engineering triumph. The bridge was used for advertisements and promotions for many products. Even 25 years later, the International Nickel Company promoted its role in the innovative nickel-steel construction, a design, as Lindenthal foretold, that proved to be stronger and more cost effective than others. (Courtesy of RIHS collection.)

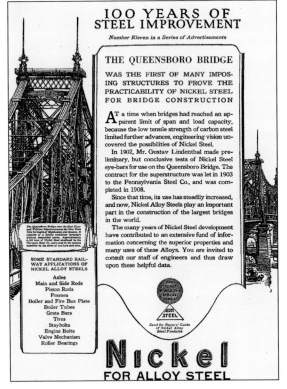

100 YEARS OF STEEL IMPROVEMENT

Number Eleven in a Series of Advertisements

THE QUEENSBORO BRIDGE

WAS THE FIRST OF MANY IMPOS-ING STRUCTURES TO PROVE THE PRACTICABILITY OF NICKEL STEEL FOR BRIDGE CONSTRUCTION

AT a time when bridges had reached an apparent limit of span and load capacity, because the low tensile strength of carbon steel limited further advances, engineering vision uncovered the possibilities of Nickel Steel.

In 1902, Mr. Gustav Lindenthal made preliminary, but conclusive tests of Nickel Steel eye-bars for use on the Queensboro Bridge. The contract for the superstructure was let in 1903 to the Pennsylvania Steel Co., and was completed in 1908.

Since that time, its use has steadily increased, and now, Nickel Alloy Steels play an important part in the construction of the largest bridges in the world.

The many years of Nickel Steel development have contributed to an extensive fund of information concerning the superior properties and many uses of these Alloys. You are invited to consult our staff of engineers and thus draw upon these helpful data.

SOME STANDARD RAILWAY APPLICATIONS OF NICKEL ALLOY STEELS

Axles
Main and Side Rods
Piston Rods
Frames
Boiler and Fire Box Plate
Boiler Tubes
Grate Bars
Tires
Staybolts
Engine Bolts
Valve Mechanism
Roller Bearings

FOR STRENGTH WHERE THE STRESS COMES

ALLOY STEEL

Send for Buyers' Guide of Nickel Alloy Steel Products

Nickel
FOR ALLOY STEEL

108

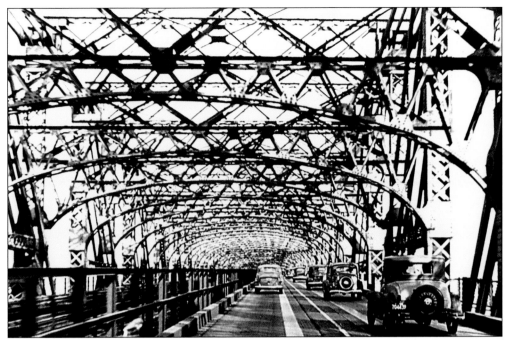

The bridge experienced heavy use almost immediately. The chief engineer of the department of plants and structures took a one-day count of the bridge traffic each year. The numbers showed a steady and dizzying climb with 459 vehicles (1909), 35,085 vehicles (1924), and 85,000 vehicles (1928). By 1916 the city began to plan for a new span across the East River, the Triborough Bridge. (Courtesy of GAHS collection.)

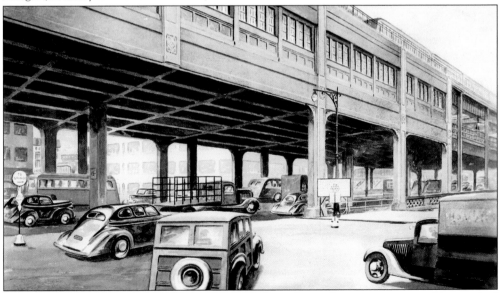

The volume of traffic on the bridge soon exceeded its design. Lanes were inexorably switched from trolley and elevated train to automobile and truck. New exit ramps were planned. In 1940, two supporting columns from the north side of the elevated platform were removed to permit easier vehicle access at the busy Crescent Street entrance in Queens. (Courtesy of Judith Berdy collection.)

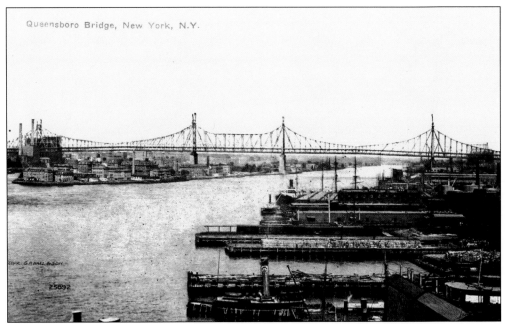

Over one third of New York's waterfront, about 200 miles, was in Queens. Because of poor transportation facilities, most of this was inaccessible to commercial improvement. The Queensboro Bridge, linking congested midtown Manhattan to the semirural countryside of Queens, created great possibilities for commercial and industrial development in that borough. (Courtesy of Stephen Leone collection.)

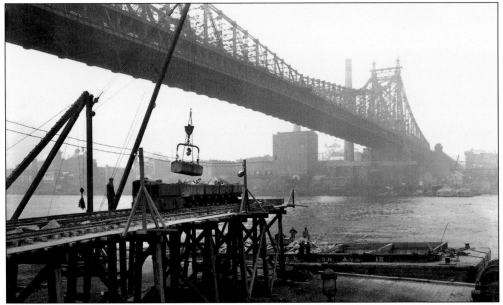

Although the beauty of the Brooklyn Bridge inspired poets from the time of its construction, the Queensboro Bridge rolled up its sleeves and went to work connecting Manhattan, the heart of New York, with Queens, its largest borough. On a smoky, foggy morning in January 1917, a barge is loaded on Blackwell's Island in a scene that looks more like an industrial town on the Ohio River than New York. (Courtesy of GAHS collection.)

The Committee of Forty lobbied to make the bridge a reality. Perhaps capitalizing on its successful efforts, in 1911, two years after the bridge opened, the Queens Chamber of Commerce formed. For most of its history, it was at Queens Plaza. Its suggestions for advancing the interests of Queens played a large hand in the making of modern Queens. (Courtesy of Queens Chamber of Commerce collection.)

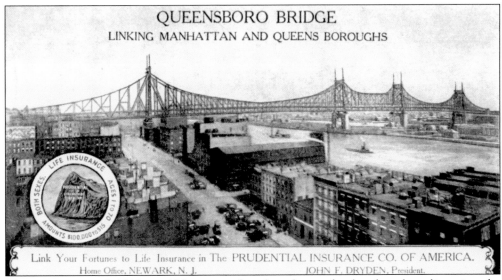

The year it opened, 1909, would become a benchmark year for decades when discussing the borough of Queens. Between 1909 and 1914, the number of factories increased by a quarter and salaried employees by an astonishing 62 percent. The records of the Bureau of Buildings of Queens show that plans filed for factory construction jumped tenfold from $1.4 million in 1910 to $14.1 million in 1919. (Courtesy of RIHS collection.)

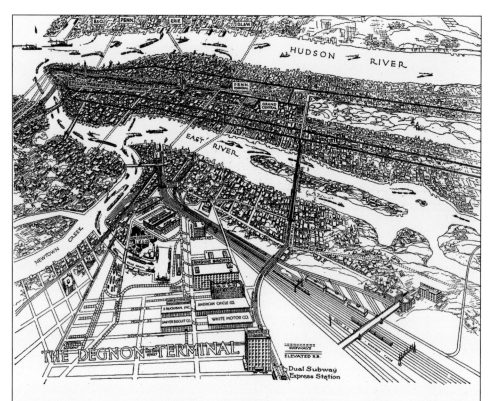

A GLANCE AT THE ABOVE TELLS OUR STORY

ALL RAILROADS AT YOUR DOOR--
CARTAGE ELIMINATED

Rapid Transit Service connecting with Boroughs of Manhattan, Bronx and Brooklyn for single fare.

Ten Minutes to Grand Central Station, Times Square and 59th Street and Fifth Avenue.

More factories have been located in this vicinity than any other part of Greater New York during the past year.

For Information Apply To
DEGNON REALTY AND TERMINAL IMPROVEMENT COMPANY
DEGNON TERMINAL RAILROAD CORPORATION
Telephone Vanderbilt 4087. 51 East 42nd Street, New York City.

Advertising for Degnon terminal shows the bridge as a vital link to New York. The *New York Herald*, in a 1916 article titled "Queens has nothing so huge as its industries," wrote, "industry gives the city its overflowing population, its million tenements, its hotels, restaurants, theatres, department stores, and shops, its wealth of gold, it multitude of spenders, its dazzling splendor, its world wide influence. Through these doors the gold of the world is flowing into the coffers of the merchants and the pockets of the workers, in this, the city of worldwide demand and unlimited supply." (Courtesy of Queens Chamber of Commerce collection.)

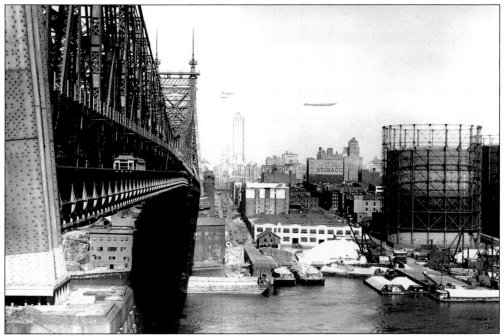

The Queensboro Bridge acted as a backdrop for the acclaimed play (later a movie) *Dead End*, a drama from the socially aware 1930s that examined life among the waterfront residents. The trolley goes about its business enveloped within the familiar ironwork of the Queensboro Bridge. Gas tanks were somehow made less menacing with three blimps hovering quietly over Manhattan. (Courtesy of GAHS collection.)

In a view near Queensbridge Houses in 1939, a manicured esplanade leads to parks at the water's edge. Convenient mass transit from the bridge and Queens Plaza made feasible this development, the largest public housing complex built in the country. The photograph was taken in 1941, shortly after the complex opened. (Courtesy of New York City Parks Department.)

The Committee of Forty suggested the city acquire the block between Second and Third Avenues and 59th and 60th Streets for a spacious entrance plaza. They opposed running the subway across the lower deck as too restrictive for automobile and truck traffic. The committee believed devoting lanes to public transportation would severely compromise the future usefulness of the bridge and development of Long Island City. (Courtesy of Queens Chamber of Commerce collection.)

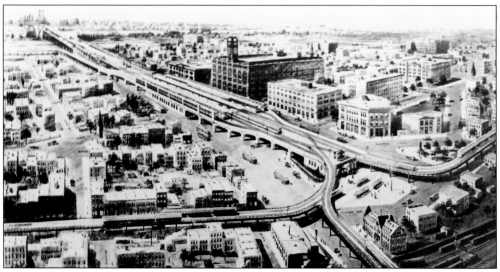

In the 1920s, the Queens Plaza transit hub was part of an ambitious effort to create a fourth business district. To ease midtown congestion, trains were to be rerouted from Grand Central Terminal across the Hell Gate Bridge to Queensboro Plaza. The crosstown line (to Brooklyn) was built in the 1930s, but as a subway line that connected an underground Queens Plaza station. (Courtesy of GAHS collection.)

In the early 1930s, Arthur Holden and Associates proposed for the regional plan of New York a terminal station for the Long Island Railroad that connected directly with the subway and elevated line in Queens. The proposal included decking over portions of the Sunnyside rail yards for a transportation center and a commercial center for a rapidly growing Long Island City. (Courtesy of GAHS collection.)

The building, which would dominate the approach to Queensboro Bridge, would be the first unit for a new business center for the borough. Underground would be the Long Island Railroad Terminal. Aboveground and running through the tower is the elevated railroad with a station in the building proper. It was proposed for the Sunnyside Yards viaduct bridge shown on page 89. (Courtesy of GAHS collection.)

The Queensboro Bridge would prove to be the last bridge built on the lower East River, and the public's attention would turn to that new generation of bridges that would later ring Queens and Staten Island, or span the Hudson, like Manhattan's great bridge, the George Washington. A tugboat towing ash past the institutions and hospitals on Welfare Island captures the gritty reality of New York mid-century. (Courtesy of GAHS collection.)

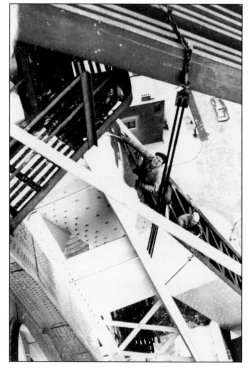

Between 1955 and 1960, as it passed its 50th anniversary, a number of changes were made to the bridge. Queensboro Plaza lost a platform, and the elevated railway and trolley tracks were eliminated. The flagpoles were removed. The center lane of the lower level had a traffic light to regulate traffic flow. Workers are painting the bridge from about that time. (Courtesy of Queens Chamber of Commerce collection.)

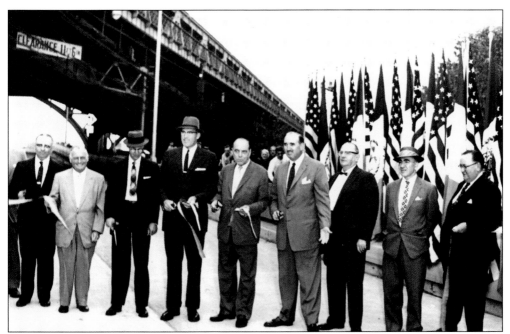

The roadways were reconfigured for 11 lanes for vehicular use (7 on the lower level, 4 on the upper level). A new ramp connected traffic with Thompson Avenue. A group of functionaries gather at a ribbon-cutting ceremony opening the upper roadway exclusively to automotive traffic at 21st Street around 1958. (Courtesy of Queens Chamber of Commerce collection.)

In 1973, a lease was granted to City Center Cinematique, designed by famed architect I. M. Pei. The project was to include three auditoriums for screening motion pictures, seating from 150 to 500 persons in each. There was also to be a 25,000-square-foot exhibition area, conference area, and research and restaurant areas. This project was never started. (Courtesy of Pei Cobb Freed and Partners Architects LLP.)

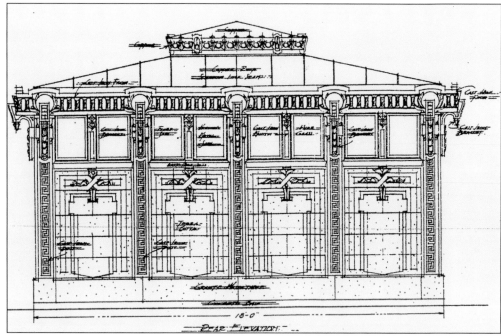

The Queensboro Bridge, in the words of one critic, is "gentle and graceful, its fairytale spires an elegant portal to Manhattan." Even details are elegantly executed, as this rendering of the kiosk from the April 1909 issue of the *American Architect* magazine. In a speech before the Municipal Art Society, engineer Gustav Lindenthal stated, "in a bridge it is not possible to separate the architectural from the engineering features." (Courtesy of RIHS collection.)

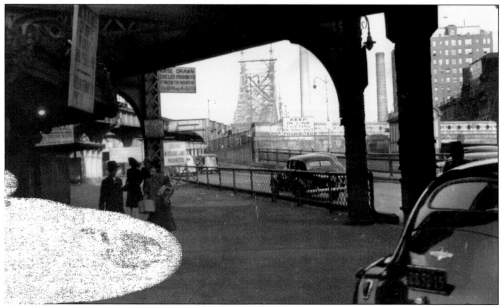

The kiosks remained in use until the late 1950s when the last trolley in New York City rattled across the bridge. Over the years, closed-up and abandoned, three disappeared. Some were destroyed by automobile and truck accidents. By 2000, only one kiosk remained at its original location. The lower track space is used for storage. (Courtesy of RIHS, Eleanor Schetlin collection.)

One of the trolley kiosks that had been at the Manhattan side of the bridge was moved to Brooklyn in 1970 and served as the entrance to the underground Brooklyn Children's Museum until 2005. (Courtesy of Judith Berdy collection.)

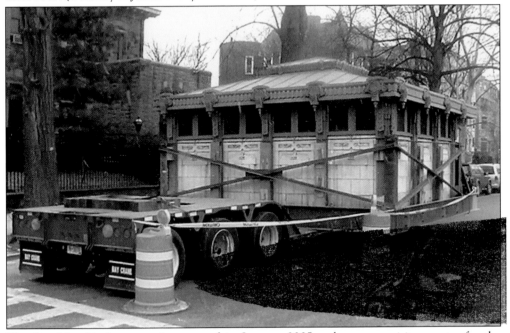

The Brooklyn kiosk was again removed in January 2005 to become a visitor center for the Roosevelt Island Historical Society. The 80,000-pound building was carefully lifted onto a flatbed truck and then went on a middle-of-the-night trip through Brooklyn and Queens to Roosevelt Island. (Courtesy of Judith Berdy collection.)

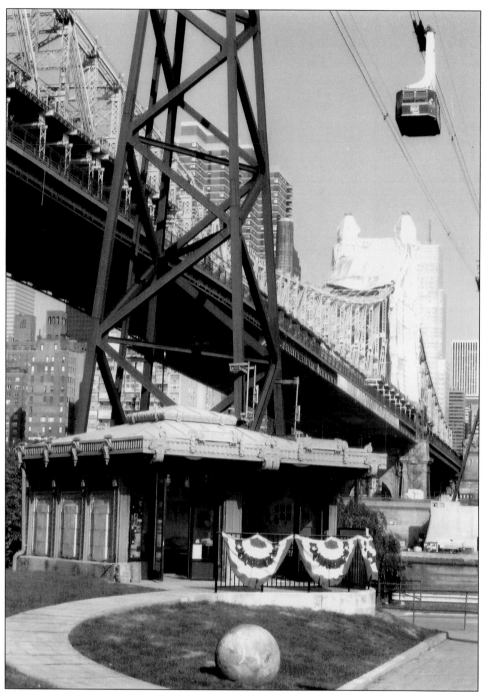

In July 2007, the Roosevelt Island Historical Society opened the visitor center, here decorated for its grand opening with the tram overhead. The trolley kiosk that had been in Brooklyn was now just a few minutes from its original location. It once served as a trolley entrance for travelers to Queens and now greets visitors arriving to Roosevelt Island by tram from Manhattan. Part of the bridge is wrapped with tarps while it was being painted for its 100th anniversary in 2009. (Courtesy of RIHS collection.)

The western pier on Roosevelt Island, just south of the Roosevelt Island Aerial Tramway, is engraved with the year 1901 on its southern side. Since it opened in 1976, thousands of tram riders have enjoyed a perfect bird's-eye view of the intricate steel and stonework of the bridge. (Courtesy of Judith Berdy collection.)

Each November about 38,000 runners participate in the New York City Marathon. The race covers all five boroughs of the city. Crossing the Queensboro Bridge from Queens into Manhattan is one of the high points. As the runners exit the bridge in Manhattan they turn east and then north into the First Avenue underpass of the Queensboro Bridge past this beautiful Guastavino-tiled arched ceiling. (Courtesy of New York Road Runners.)

A granite fountain built in 1918 for a farmers market beneath the Queensboro Bridge was rededicated in June 2003 after restoration. Evangeline Blashfield was the model for the fountain's glass mosaic of a woman with a cornucopia. Her husband, artist Edwin Blashfield, designed the work. (Courtesy of Municipal Art Society.)

Built in 1930 for New Bedford, Massachusetts, this streetcar was purchased in 1947 for use in New York City on the Queensboro Bridge. It was the last streetcar to operate in regular passenger service in New York State. Number 601 is part of the collection of the Trolley Museum of New York in Kingston and awaits restoration. (Courtesy of Judith Berdy collection.)

"These finials or crowns were originally designed to hold a 30 foot flag mast that was two feet in diameter," says bridge photographer Dave Frieder, in his photograph titled "Upper Platform and Crown." Until the 1940s, the city proudly flew American flags from the towers. The department of transportation removed them in 1960. Bridge fans hope the finials will be restored someday. (Courtesy of Dave Frieder collection.)

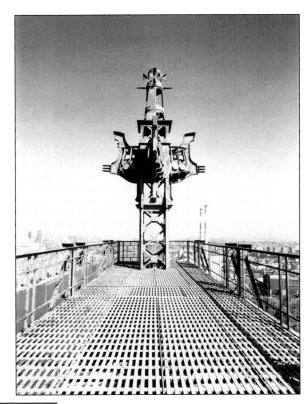

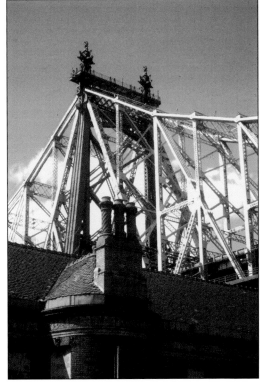

Two officially designated New York City landmarks, the Terra Cotta building and the Queensboro Bridge, stand beside each other on Vernon Boulevard in Long Island City. Both recall the engineering marvels and pace-setting architecture that not only defined their era but also are still hallmarks of the New York building industry. See page 37 for an earlier view. (Courtesy of Robert Singleton collection.)

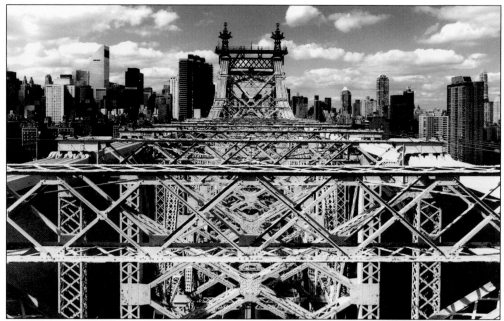

Entitled the "Sea of Steel," photographer Dave Frieder states, "It was a perfect spring day with deep blue skies and white clouds. All I saw was this massive sea of steel. The clouds actually seemed to hold the image together as they surrounded the top of the next tower." (Courtesy of Dave Frieder collection.)

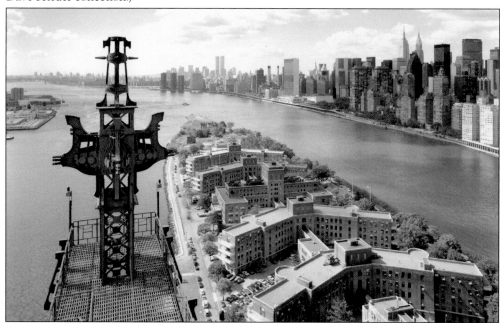

Dave Frieder calls this image the "Crown and Clouds, New York City Skyline." He narrates, "It was another perfect day on the top of the bridge and for this image I climbed to the very top of the north crown or finial on tower number three. This vantage point afforded me a great view of the entire Manhattan skyline with the Twin Towers in the background and Roosevelt Island in the foreground." (Courtesy of Dave Frieder collection.)

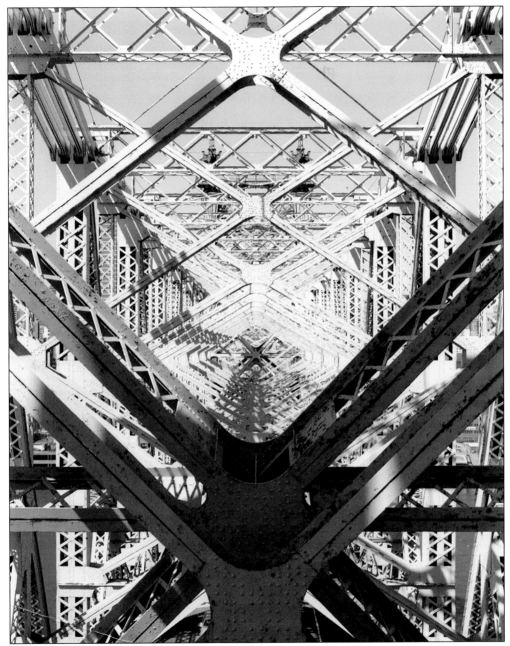

To create "View Through Trusswork," Dave describes, "I had to climb through some boxbeams and perch myself on a large gusset plate. From that point I was able to get this great view looking though the trusswork from tower three to two. This section passes over Roosevelt Island and it is relatively flat so it gives this tunneling effect." (Courtesy of Dave Frieder collection.)

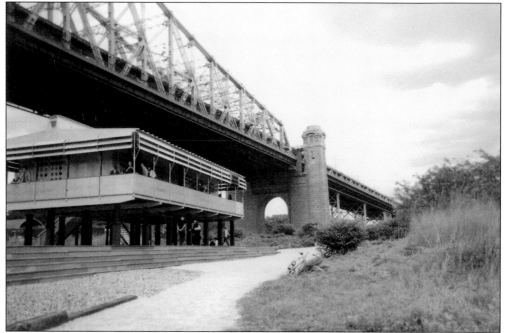

The Maison Tropicale was a rare mid-20th-century prefabricated home by French designer Jean Prouvé and was one of only three built. Shipped in six containers from its first home in Congo-Brazzaville, it was immaculately restored. Christie's, which auctioned the house for more than $4 million during the summer of 2007, stationed it for a few weeks on the Queens waterfront just south of the Queensboro Bridge. (Courtesy of Frank Carrado collection.)

Although Long Island City owes its existence to the East River, it is mostly cut off from its waterfront, first with estates for the wealthy and then later power plants, public housing, warehouses, and factories. Plans call for walling off the waterfront again with private luxury development. Here one can glimpse briefly the East River waterfront as a public park, an amenity enjoyed across the river in Manhattan. (Courtesy of Frank Carrado collection.)

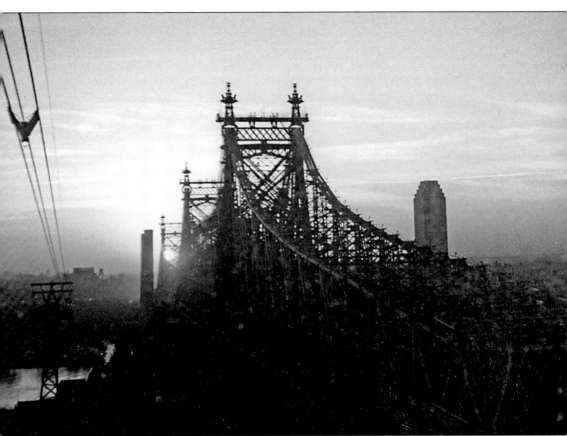

Dawn shines through latticework on the bridge. The span is a tribute to the skill of those men, armed with little more that raw courage, who walked its beams while tons of steel swung about them. Although their ranks were drawn from around the globe, when they marveled at their completed work, its flags snapping in the wind, they became Americans of one temper and spirit. The Queensboro, in its completion, spirit, and design, is the quintessential American bridge: massive, yet graceful, an iconic symbol of a great city, yet unassuming as it goes about its work. "Without architecture of our own, our civilization has no soul," said architect Frank Lloyd Wright. As in other cities, a public waterfront park at the Queensboro Bridge would be a fitting monument for future generations to admire those, to paraphrase Andy Rooney, who "spanned the river with a poem." (Courtesy of Richard Melnick collection.)

DISCOVER THOUSANDS OF LOCAL HISTORY BOOKS FEATURING MILLIONS OF VINTAGE IMAGES

Arcadia Publishing, the leading local history publisher in the United States, is committed to making history accessible and meaningful through publishing books that celebrate and preserve the heritage of America's people and places.

Find more books like this at
www.arcadiapublishing.com

Search for your hometown history, your old stomping grounds, and even your favorite sports team.